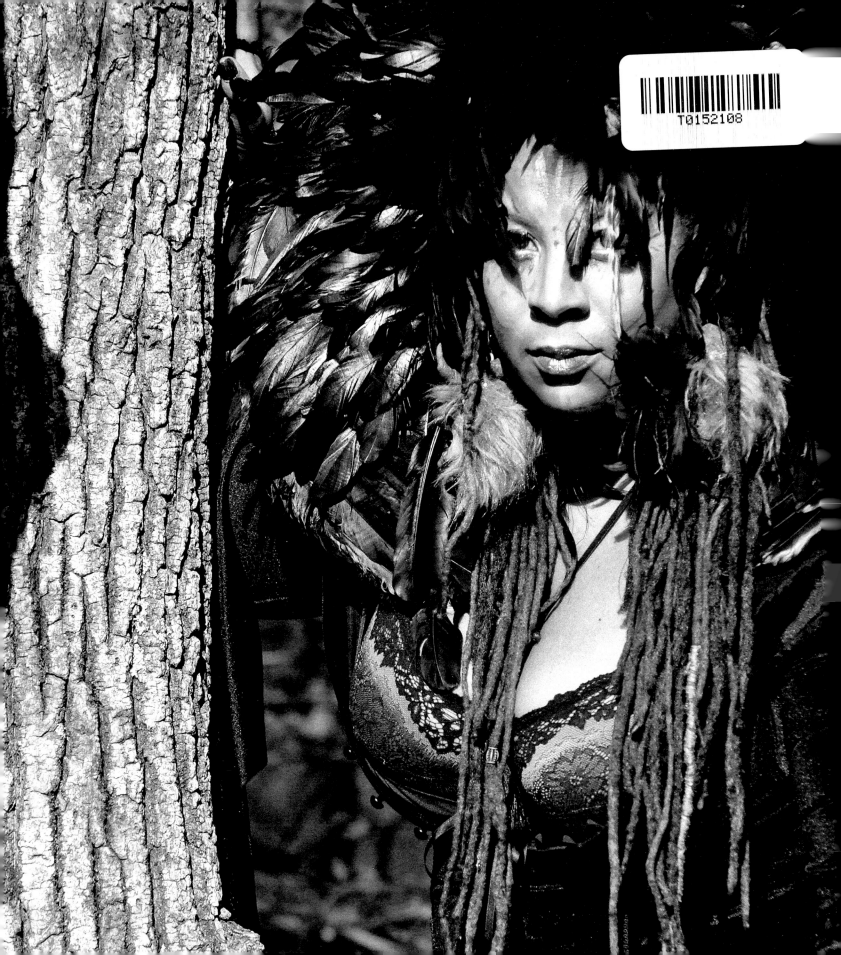

DARK GODDESS

An Exploration of the Sacred Feminine

Essays By

Emily Bernard

Vicki Brennan

Shanta Lee Gander

Fleming Museum of Art | University of Vermont | Burlington | Vermont

Published on the occasion of the exhibition

DARK GODDESS: AN EXPLORATION OF THE SACRED FEMININE
On view at the Fleming Museum of Art, University of Vermont
February 8 – December 9, 2022

This catalogue is supported by a grant from the Vermont Arts Council and Vermont Humanities.

This exhibition was made possible by the Kalkin Family Exhibitions Endowment Fund and the Walter Cerf Exhibitions Fund.

This catalogue is published by the Fleming Museum of Art and distributed by ISD.

Fleming Museum of Art
University of Vermont
61 Colchester Avenue
Burlington, Vermont 05405
(802) 656-0750

ISD
70 Enterprise Drive
Bristol, Connecticut 06010
www.isdistribution.com

Editors: Shanta Lee Gander and Andrea Rosen
Design, Production, and Object Photography: Chris Dissinger

ISBN 0-934658-16-1

Printed by Villanti Printers
Milton, Vermont

As the new year launches, we are honored and excited to present Shanta Lee Gander's multipart exhibition, *Dark Goddess: An Exploration of the Sacred Feminine*, at the University of Vermont's Fleming Museum of Art. Shanta's artistry, expressed through photography, poetry, fiction, video, and curatorial interventions, offers a powerful experience that engages the eye, intellect, and emotions.

In her photographic series *Dark Goddess*, the artist's striking portraits emerge from collaborations with her models and are accompanied by their own words and voices, excerpted from Shanta's interviews with them. Through this co-creation process, she turns on its head the conventional, extractive relationship between photographer and subject.

In *Object-Defied*, Shanta has selected objects from the Fleming's collections to be exhibited in conjunction with her photographs. They are contextualized by her own writings and the writings of others, which foreground the cultural contexts and lived experiences of those from whom these objects were taken, in the course of European colonialism and American settler colonialism, in order to fill western museums. In *Object-Defied*, Shanta revitalizes a historical literary genre – "speaking objects" – giving voice to Fleming Museum artifacts that engage one another and the viewer. These speaking objects reveal truths that traditional museum texts, including the Fleming's, have never dared to reveal.

I want to thank Shanta Lee Gander for the power of her artistic vision and the generosity with which she has shared it with us and our visitors, and Andrea Rosen, the Fleming's Curator of Collections and Exhibitions, for helping to realize Shanta's vision. Thank you to Margaret Tamulonis, the Fleming's Manager of Collections and Exhibitions, and to Suzy Zaner, in her first project as the Fleming's new Exhibitions Preparator.

We are grateful to UVM's Julian Lindsay Green & Gold Professor of English, Emily Bernard, and UVM Associate Professor of Religion Vicki Brennan, for their insightful contributions to the exhibition catalogue; and to the Fleming's Curator of Education and Public Programs Alice Boone for her conversation with Shanta included in the catalogue. Our collective gratitude to the Fleming's Assistant Director for Outreach and Visitor Engagement, Chris Dissinger, for his exceptional design and production of the catalogue to document this important exhibition. Thanks to the entire Fleming staff for their support of this project from their respective departments.

As always, we deeply appreciate the ongoing support of Fleming Museum exhibitions made possible by the Kalkin Family Exhibitions Endowment Fund and the Walter Cerf Exhibitions Fund. Their support makes it possible for the Fleming to present the work of groundbreaking artists such as Shanta Lee Gander. This catalogue is supported by a grant from the Vermont Arts Council and Vermont Humanities.

JANIE COHEN
Director
Fleming Museum of Art

eclaring and asserting our freedom from oppression necessitates the acknowledgment of that oppression.

Those dualities of freedom and oppression are expressed by the subjects of Shanta Lee Gander's *Dark Goddess* photographs—Kahywanda, DonnCherie, Re, Heather, Renee, Jamie, Bailee, Caighla, and Alyse—as they reflected back on the experience of shooting with her. Their pride in the way they were able to express the strength, anger, sexuality, violence, darkness, control, and beauty of the Goddess is often shadowed by the acknowledgement that a patriarchal and white supremacist society does not and has not let them be that before. The models express gratitude to Shanta for allowing them to manifest the powers of the Goddess through this project and to subsequently carry Her aspects with them through their lives. Yet "gratitude" and "allowing" suggest a degree of submissiveness inappropriate to this project, given that the subjects were active collaborators in their own presentation: costume, setting, props, pose.

The power differential between photographer and subject is one that Shanta acknowledges, and intentionally explores, even as she attempts to subvert it: another duality expressed in this project. Is it possible to wield a camera, a tool of surveillance and control, a tool of the white male gaze, to subvert those ends? What does it mean for a woman of color, so often the object being controlled in the ethnographic photography tradition Shanta references (a tradition represented in abundance in the Fleming's collection), to step into the position of power of the presumed white male photographer? In Shanta's words, "the seen body sees, questions, and responds." Can we create a new photography that exists outside those power relationships? Or by declaring and asserting our freedom from them, do we inherently acknowledge our recognition of them and thus the impossibility of ever escaping them? How can we keep disrupting them nevertheless?

With each expansion of the *Dark Goddess* project, including the considerable amount of new material generated for the Fleming Museum exhibition, Shanta plumbs the depths of these questions while continuing to find ways to disrupt those power relationships. For example, she involved her subjects in the very contemplation of the dynamics of the camera and the gaze, the photographer and the subject, with one of her interview prompts: "What was it like to be seen by me? What is it like to be seen by others through these images?"

In her creative writing for this catalogue and for the exhibition labels that accompany both her own photographs and objects from the Fleming's collection, Shanta continues to flip the power dynamics of the seer and the seen. In her texts, the Goddess speaks back; She warns, She cajoles, She threatens. The Goddess continues to speak to us through Shanta's film montage for the exhibition, in which she compiles footage of the sacred feminine in art and pop culture, thus destabilizing the cinematic male gaze articulated in Laura Mulvey's iconic essay "Visual Pleasure and Narrative Cinema," a key reference for Shanta.

My favorite reversal of power comes from Shanta's curating of objects from the Fleming Museum's collection: material culture objects of sacred feminine power; restrictive women's clothing and restrictive icons of white womanhood; exploitative photographs taken by white photographers of indigenous Samoan women. Shanta writes from the voice of the subjects of the photographs, of the Goddess manifested in the object; sometimes of the objects themselves. These voices speak to each other about their experiences. They talk back to the viewer, thereby undermining what was formerly a one-way gaze. They talk back to the very Museum that has held them for so long, dictating the terms of their display and interpretation. This is something that no curatorial label that I write could ever do.

All of these questions about the nature of systemic power, and expansion of the project into more media and forms, do not dull what is from the first a tremendous artistic accomplishment: a captivating suite of photographs of contemporary women embodying the dark sacred feminine, in contravention of societal dictums for propriety and positivity.

I am grateful to Shanta Lee Gander for sharing her brilliance with us; she was among the most conscientious and generous collaborators I have ever had the pleasure to work with. I want to wholeheartedly thank the entire Fleming Museum staff, who keep on giving of their energies and expertise: Janie Cohen, Chris Dissinger, Alice Boone, Margaret Tamulonis, Stephanie Glock, Emily Stoneking, Phil Morin Jr., Suzy Zaner, and recent departures Jeff Falsgraf and Cynthia Cagle. Thank you to the talented and generous Andrew P. Frost and Jennifer Koch, who leant their printing and framing expertises, respectively. I want to thank UVM faculty members Emily Bernard and Vicki Brennan for their contributions of writing and thinking to this catalogue, and to many other Fleming projects besides.

ANDREA ROSEN
Curator of Collections and Exhibitions
Fleming Museum of Art

Dark Goddess Speaks

Dark Goddess Speaks

by SHANTA LEE GANDER

It was important for this iteration of *Dark Goddess* to include the women involved with this image-making. In talking with all of these collaborators, they were asked three main questions:

> 1. Now that you've participated in *Dark Goddess* as a model and have your image as a part of an exhibition: (1) What was it like to be seen by me? (2) What is it like to be seen by others through these images?

> 2. In this ongoing work with the *Dark Goddess* exhibition, I am thinking a lot about the concept of the sacred feminine. This is another two-part question: (1) What is your definition of being a Dark Goddess? (2) Do you see a connection or similarities to the idea of the sacred feminine?

> 3. Anything you want to add?

In some instances, we talked about the self-fashioning that was particular to each individual, in terms of what inspired them to curate their specific look for their shoot.

If individuals were not able to participate in the interviews, the images were paired with my original poetry inspired by conversations during the shoot alongside my ongoing thinking about the Dark Goddess.

The interviews have been lightly edited for use in this publication with the goal of maintaining the authenticity of each individual's voice.

Bailee as *SHE... KILLER OF BAD MEN (II)*, 20

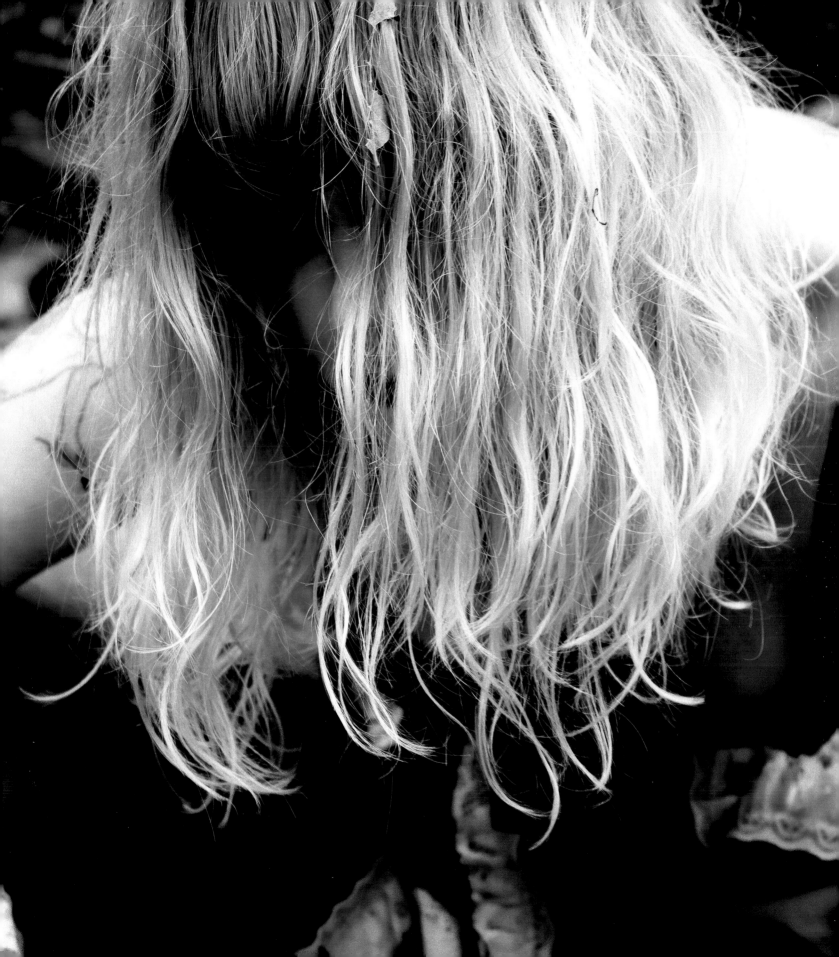

OBEAH'D
Kahywanda

The photo session with Alyse and Kahywanda was rare among the Dark Goddess shoots because I reached out asking them to participate with my own idea in mind. What drew me to having them together for this session is the fact that they have had a tight bond since our childhood. Their bond has included their penchant for speaking their own language to each other, even when others are around. I'd been thinking about their world-making as it connected to the supernatural concept of the Obeah in Jamaican culture.

What was it like participating in the shoot and how do you feel being seen by others?

The shoot was exciting. I wanted to know what people were going to think about the photographs? If they felt any energy from looking at the photographs?

What drew you to this particular look for the photoshoot?

What drew me to choosing that look? The statement.

The statement that I felt that the picture was going to make to people seeing it.

What was it like being in the photograph with your cousin, Alyse?

Powerful. I was working off of Alyse's energy and she was working off my energy making it even more powerful. Again, I have to use the word energy and powerful. I keep using the word power, but when I look at the pictures, that's what I see... power. Strength. I see life.

Also, doing this photoshoot with Alyse was an accomplishment and the reason why I'm saying that is because we are both cancer survivors. For me to see her in that way, and for her to see me in that way...it meant a lot to both of us. Like, "We made it. We did it."

Is there anything else you want to share with the audience?

This has nothing to do with the occult. The reason why I am saying that is because I remember when you took us to see the photographs at the other exhibition [at the Southern Vermont Arts Center], there was a couple standing in front of one of the pictures and that was the statement they made, they got an "occult feeling." The Dark Goddess is more about your inner feelings, what you put into it. I put a lot of positivity into the picture. I was in nature, I love nature, I was basically at home [during the photoshoot].

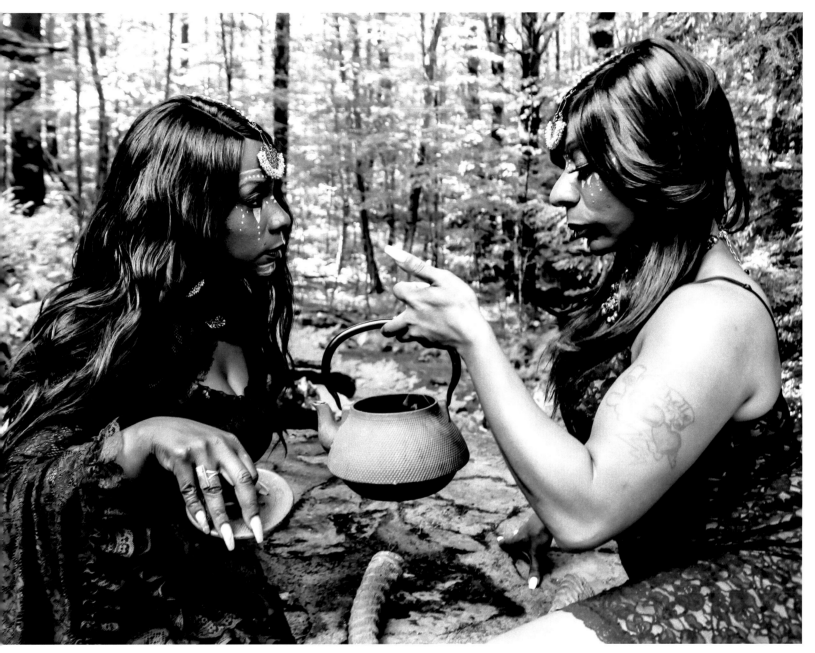

Kahywanda and Alyse as *OBEAH'D (I)*, 2021

CROW GODDESS
DonnCherie

"Goddesses make noise, take up space, be your amazing selves. Be unapologetic and hold me to the same if you catch me being polite in a situation where politeness is not warranted. Call me on that."

— DonnCherie

Being seen by you was not that different because you have been able to see me from the beginning, this is why we're friends. It was cool to be able to share the dark that we share through our laughing, our stories, and trekking through the woods. And there was a lot of honesty in those talks.

This experience was awesome for me and it was in the middle of all the initial scary pandemic. It was good to connect with a friend with all the upheaval that was happening within black communities medically and mentally. In the midst of all of the other insanity involving people getting executed by the police. And people who look like us going through our grieving process for all of these souls that we are seeing all over social media and the news. So it was good to be able to connect with another woman of color, another Black woman.

To be seen by others through your lens? I sometimes have trouble articulating to a wider audience that shadow place, where I live most of the time, because people are kind of skittish. And when they see that, or hear that, it suddenly makes them slightly defensive. It makes me hold back, especially once you see that people can't handle a certain side of you.

I do see a connection to the sacred feminine because you can't have one without the other. And maybe this is me answering the two part question with one answer... the love and light thing really pisses me off. I never identified with it. The toxic positivity.

Sometimes, you need to embody the chaos, you need to be able to sit with the chaos, not constantly chasing the positive, the "*No, I never let those things get to me*." NO. They get to me. I get angry. I have extreme highs and extreme lows. And I can sometimes focus enough to write lyrics about it. Sometimes I just need to be left alone to cry, rage, take a walk in the woods, or whatever just to be with it to know why.

There are some things that happen in this place that should make you mad, that make you scared. You should be scared for the future. You should be hopeful for the future and accepting that humanity has been light and dark, but there are some things about us [as a species] that are batshit crazy and we need to address it. Acknowledge it, cut the crap. We need to look at it. Sit with it. Talk about it. Do something about it and be better. But until somebody gets mad, we can't do that because while we're all just trying to save face and say the right thing or give the right answer, nothing gets done.

And I am not an activist kind of person but the fact of my very existence makes me an activist, which means I will survive and live and thrive in your face. Regardless.

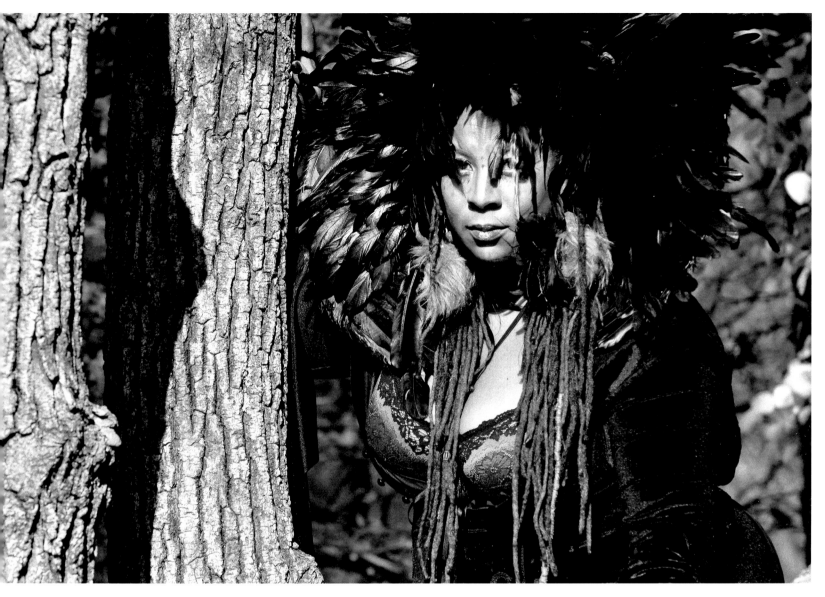

DonnCherie as *CROW GODDESS*, 2020

IN THAT ONE STORY, EVE...

Heather

"Being someone with a history of body dysmorphic disorder, it's why I've made the choice to model in various avenues with artists in the community. Choosing to do this specifically, while pregnant, was a new way of approaching self-love. It was really profound because with the embodiment of the theme, I was able to bring a fierceness. It also was visceral. I had a feeling of ownership of space, just having space of my body."

— Heather

Why Eve?

I wanted this to be a portrayal of Eve on her own because Eve always has the Adam companion. Also, Eve's whole personal story of being the instigator of sin, all the shame that she gets for that. I wanted to take that shame and show it had no power. The choice to be female. The choice to be a woman, the choice to be naked, even though I was wearing the leaves, it was still liberating.

Eve and the connection to the personal...

I was raised with Christian values as a child going through puberty and my mother was really intense about it. Being introduced to Christianity right at the time that you're becoming a woman is such a strange combination of "I'm becoming a woman," "I'm becoming fertile," "I'm doing this and that." I was also being told that we are supposed to be governed by the laws of men, so it was a really confusing time.

On the meaning of Dark Goddess:

The Dark Goddess is all that is mysterious about being a woman that intimidates people who are pretending to be pious or pretending to be pure. We all bleed. We all have these bodies that do these things that we have to constantly maintain. And the Dark Goddess to me is harmony, worship and nurturing of our bodies through all stages, from birth to puberty. I think that the Dark Goddess is also related to all those different transitions of womanhood as well.

As someone who's explored a little bit of Hinduism, a little bit of the Celtic paganism, there are so many Dark Goddesses. They are the ones we call upon for justice and strength in the face of victimhood. And the Dark Goddess is so much of that strength like, "You are not going to eff with me. I'm a bad bitch."

On *Dark Goddess* within the larger cultural surround:

I feel like this project is a resurrection of sacred femininity. It's a rehabilitation of what has been shamed about the darkness of femininity. Because as we know, all the cultures that

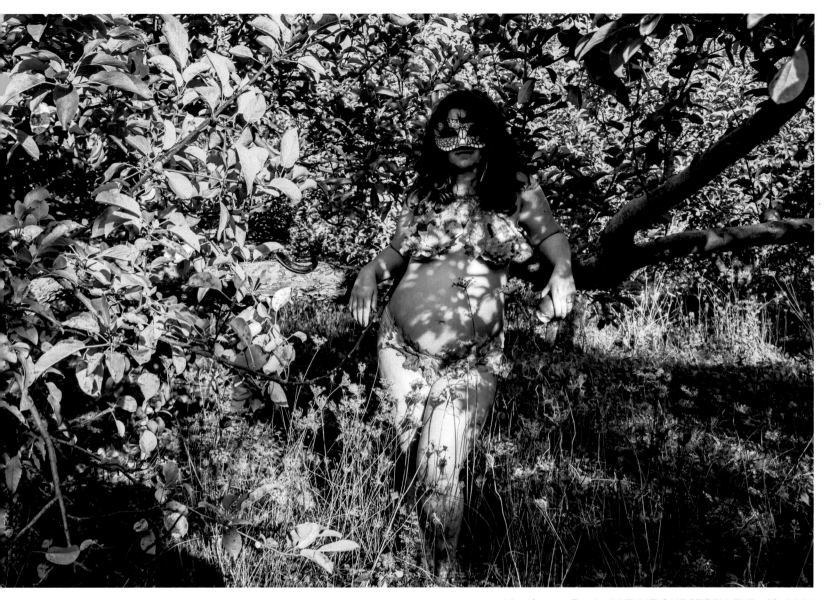

Heather as Eve in *IN THAT ONE STORY, EVE…(I)*, 2021

harbor and manifest so much of that feminine energy are the ones who have faced a lot of the genocides, have been attacked, enslaved and all of these things.

Is there anything else you want to share with the audience?

I never considered myself to be someone who would want to conceive, to have a child. I honored the choice, because I did make the choice to do it. Between the state of the world, the long history of mental illness with my mother and my mother's mother, I think so much of it was recalling "The Mother" while telling myself, *I'm strong enough to take this on.*

I am strong enough to take motherhood on, regardless of how mentally ill my whole lineage of motherhood appears.

It's facing the maternal narcissist and telling it, *You don't thrive here.*

THE MORRÍGAN

Re

"One of the reasons I'm really drawn to her is that she defies and shatters the cultural limitations and these strict concepts of what it is to be feminine."

— Re

What it was like to be seen by you in this process? It was a conduit opening up for me. I felt like I was channeling this energy. For me, the Dark Goddess, the Morrígan, is something that transcends time. She transcends even the concept of the triple goddess, the maiden, mother, crone. This is the energy of inevitability in terms of being a goddess of fate, goddess of the crossroads and death.

There's a lot of disagreement among scholars about the exact etymology of the name. There's a couple of different interpretations based on the first syllable of the word. From the Old Irish, it means Phantom. In Middle Irish, Phantom Queen became the primary interpretation of her name. Also from the Anglo Saxon word *maere*, which still survives in modern English in the word nightmare. *Mór* means great, and *rígan* means queen. This is a connection with the Latin word *regina*, meaning queen.

The Morrígan was also known as a goddess of war and death as well as fate, so she is the continuum of life. Additionally, she represents something that is far beyond what cultural norms accept in what is considered the feminine. As individuals and as women, to know that there is this universal well of power that we are naturally tapped into, that we can explore that within ourselves, is exciting.

I see [The Morrígan] as a platform because as human beings we all have our shadow, and to move beyond our trauma we all have to learn to go deeply into it and explore it. I believe that the Morrígan and the Dark Goddess, for me, is a vehicle to actually explore my own trauma and explore my own demons. Through that, that's how healing can take place.

She is a well of personal power for me.

Re as *THE MORRÍGAN*, 2020

SHE... KILLER OF BAD MEN

Bailee

Dead men can't cat call. When I spoke it, I meant it

And by meaning it, come close...Closer
Try me. My writ is embossed on my...

— Shanta Lee inspired by SHE... **KILLER OF BAD MEN**

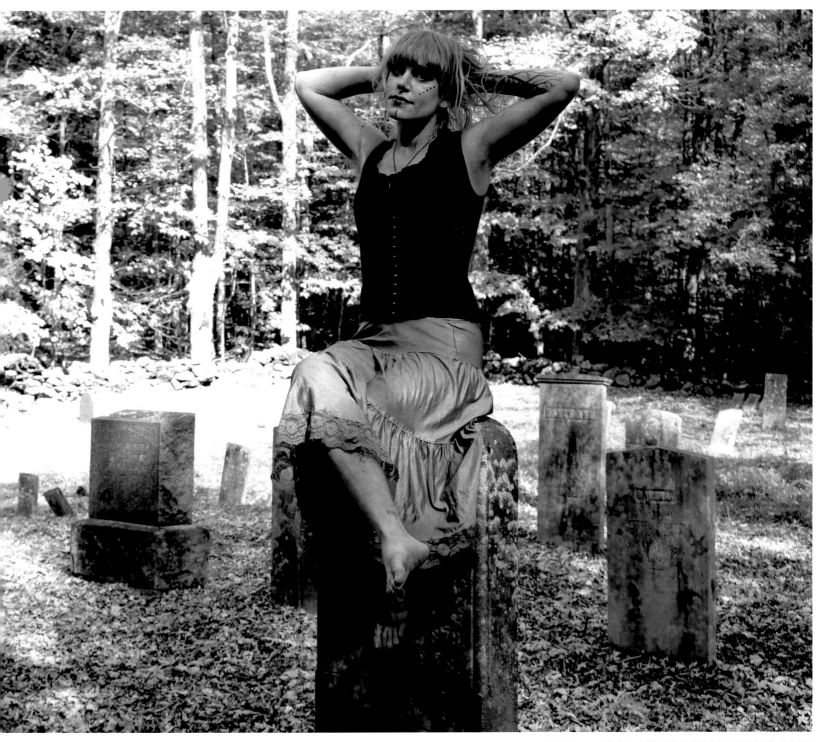

Bailee as *SHE... KILLER OF BAD MEN (I)*, 2020

HECATE
Renee

"In our current culture, darkness has gotten a really bad rap. People think of darkness as something harmful versus something that is necessary and healthy. We sleep in the dark, that's when a lot of our healing happens. Getting in touch with the aspect of the Dark Goddess brings us to a liminal place, between the two worlds where a lot of us like go to without realizing different aspects of our lives."

— Renee

What was it like to be seen by me? What is it like to be seen by others in this way?

I felt really natural in front of you. At the same time, I feel like you were able to see deeper into me than other people normally do. Being seen by other people makes me nervous.

Tell me more about your work, because you are researching this topic right? Also, what is your personal relationship to Hecate?

I'm exploring the aspects of the demonization of the feminine which is a part of what I see that the "love and light" culture still propagates. That culture feeds off of this demonization especially when they say, "We're sending like good vibes and love and light to you." It's like, NO. Sometimes destruction has to happen and when it does, it can not be deemed evil. Also I think it's dangerous to use the word evil, especially when describing anything that has to do with

aspects of femininity, because it has been used against us.

People have been murdered because of a philosophy of evil, mostly women. There are these different aspects of the demonization of women, take Hecate for example, she is the goddess of witchcraft, necromancy and poison.

Probably from the age of four years old is when I started contemplating these things like altars to a moon goddess and mixing up herbs in my yard calling it magic. It's always been there. There she is next to my bed [*gesturing to her night stand*]. These are things that have held a place within my consciousness since the time I was able to understand that there was something other than exactly what we see.

I grow poisonous plants that I use in different things, including witchcraft. It has always been a natural thing for me to connect to Hecate, it wasn't forced in any way to be drawn to her as a child.

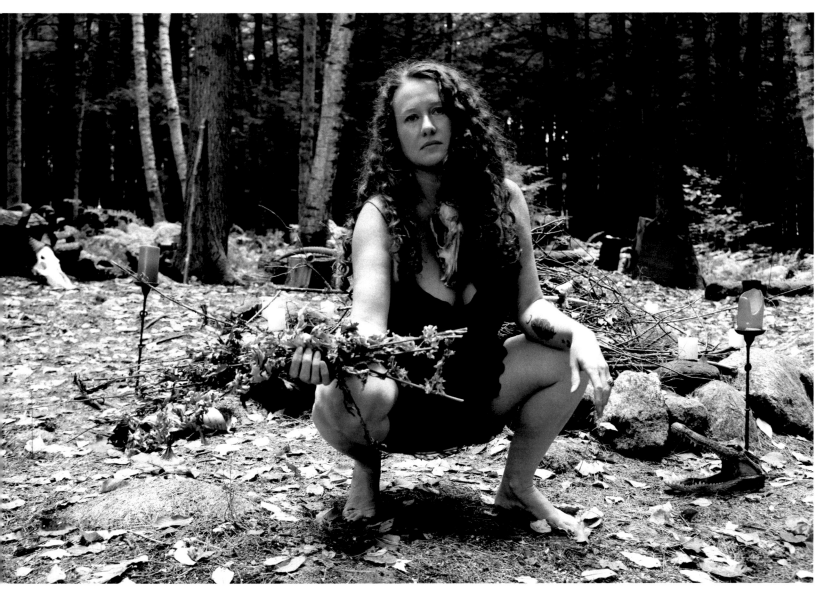

Renee as *HECATE*, 2020

For those who are not familiar with Hecate, who is she as a Goddess?

Hecate is layered. There are different things connecting her to Greece and to what we know as modern-day Turkey. Other things that go back even further, so there are different thoughts about where Hecate came from. I think perhaps she came from all these places and she is a part of our collective consciousness. She also is a triple goddess which we see in a myriad of different cultures. For example, in Ireland, Brigid is a triple Goddess as well. This concept has even been taken by the Catholic Church for the Father, Son, the Holy Ghost, they straight up robbed my bitch with that.

Is there anything else you want to share with the audience?

Maybe a suggestion to sit quietly with the thought of what darkness means and maybe shed some of the layers of what Christianity has told us that darkness is. Get in touch with the liminal spaces that are inside of us, through darkness.

DARK APHRODITE
Jamie

This isn't anything you will be able to unsee.

— Shanta Lee inspired by DARK APHRODITE

I've shot with you before but this brought something else out of me. It was like I was a whole different person. I wanted to be sexy and freaky. I wanted to draw attention. A Dark Goddess is a woman who's empowered, who takes control, who knows what she wants.

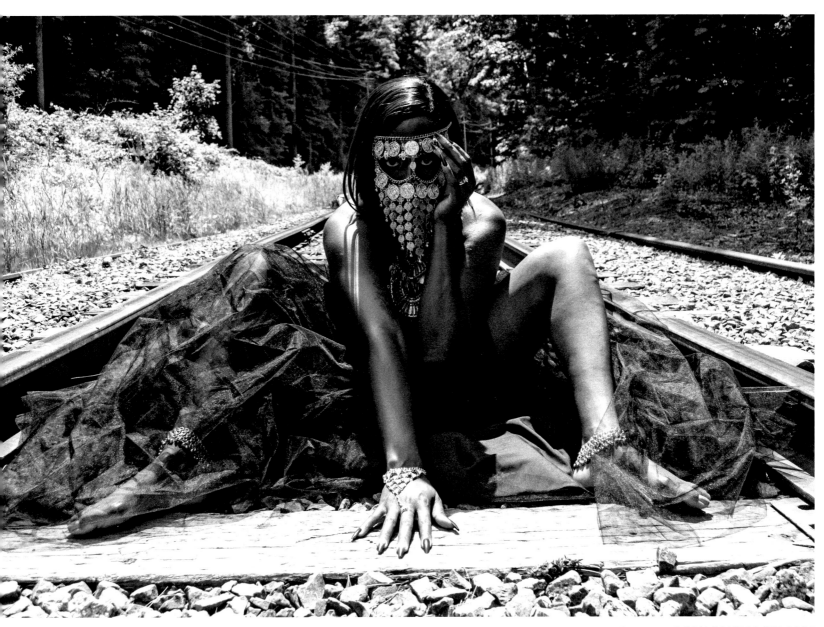

Jamie as *DARK APHRODITE*, 2021

YOU WILL OBEAH (II)
Alyse

I am not a tale told by digital oracles. I am not a tale passed from those whose tongues can't twist to tell about before.

— Shanta Lee inspired by YOU WILL OBEAH (II)

It was an unreal moment because I didn't think that I was going to fit the image of a Dark Goddess. I didn't understand what the Dark Goddess was at that time, but the way you kind of walked us through it... that was a moment that I felt that I was that person. I was that Dark Goddess. It was powerful and it felt like, "I actually did this and I actually look beautiful in it."

A Dark Goddess is a powerful woman. A sexy woman. A woman who knows and takes control of her life and any aspect in it. Someone who knows what she wants.

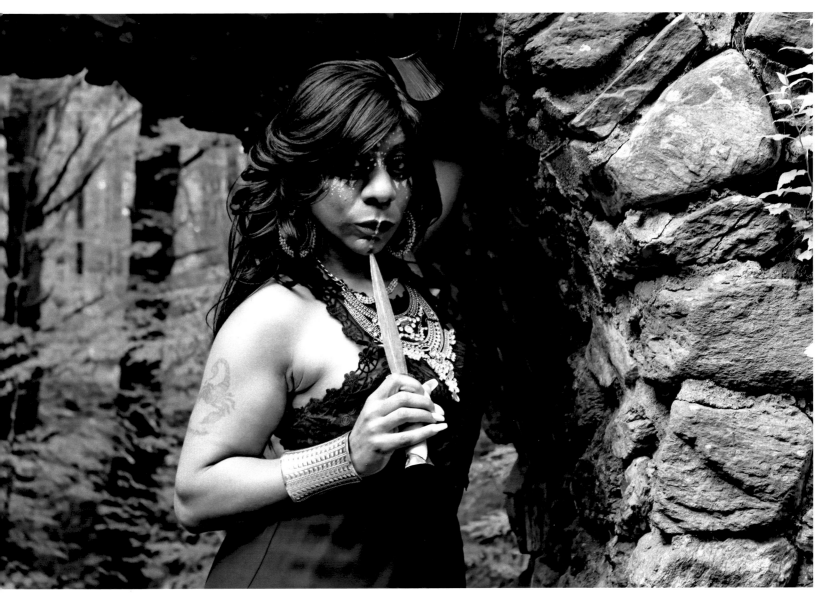

Alyse as *YOU WILL OBEAH (II)*, 2021

ORIGINAL BERSERK
Shanta Lee reflecting on Caighla as a Dark Goddess Catalyst

One man's mad, nightmare
Named for the way I unmake
Named for the way I be Berserk I, Original Queen of Crazy

— Excerpt from "I, Crazy" by Shanta Lee

This is where the origin story of this exhibition begins. It was late summer of 2020 and I'd not picked up my camera in several months, not sure how to navigate making images of people or abandoned places in the middle of COVID. Caighla and I have worked together before and always talked about doing another collaboration. As we started to solidify plans for a late summer shoot, I was not thinking that this would launch me into the exploration of the Dark Goddess. The Dark Goddess was still very much an idea that I would revisit from time to time after initially talking about the idea with a friend several years ago.

After the photo session with Caighla, and after spending some time with the images, something clicked. Working with Caighla was a catalyst in a number of ways: (1) it inspired me to remember what was possible, even while feeling so trapped during the pandemic and (2) it launched me into seizing the moment to dive into something that was both exciting and intimidating for me as an artist.

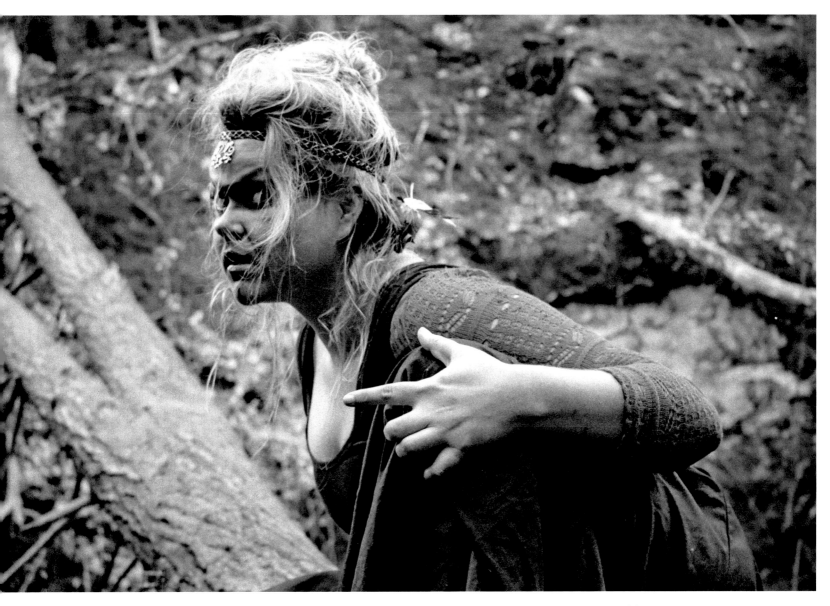

Caighla as *ORIGINAL BERSERK*, 2020

YOU WILL OBEAH (I)
Kahywanda

You must be awake to follow me, believe me as I tell you...
you wouldn't understand

I am the riddle you can't consume

 — Shanta Lee inspired by the YOU WILL OBEAH (I)

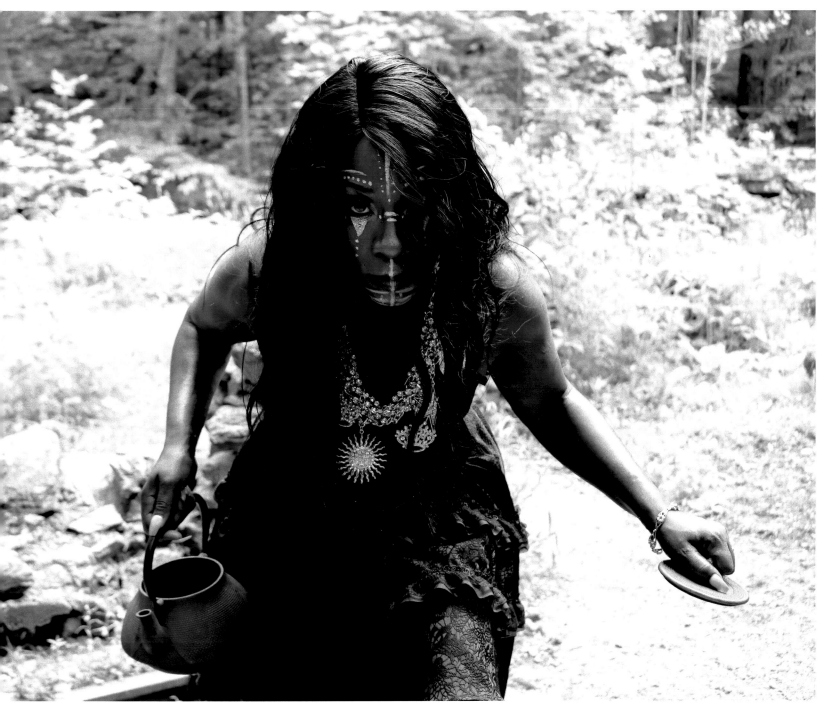

Kahywanda as *YOU WILL OBEAH (I)*, 2021

Object-Defied

The Conversation

Wedding dress (1857) in conversation with *The Greatest Mother in the World* (1918)
poster in conversation with *Americans All!* (1919)

"'I've got out at last,' said I, 'In spite of you and Jane. And I've pulled off most of the paper, so you can't put me back!,'"

-Charlotte Perkins Gilman, "The Yellow Wallpaper," 1892

"...she drinks the blood of the victims who were formerly her children."

-Anne Baring and Jules Cashford, *The Myth of the Goddess: Evolution of An Image*, 1991

"I am the she, the lord of my child."

-*The Thunder: Perfect Mind*, before 350 C.E., discovered with Gnostic manuscripts in 1945

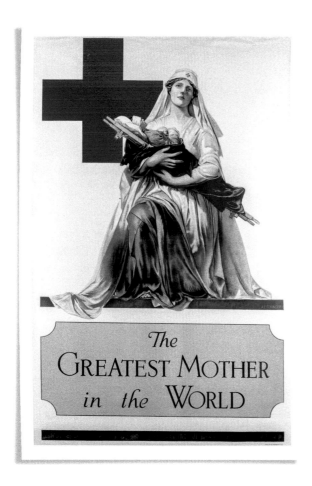

"I am pious. I am pure. I will ob..." Great Mother gives a stern look to Wedding. Wedding cringes continuing, "I obey. I..." Great Mother unfurls the butcher knives of upset into voice, "Don't do it child. You don't know what you speak. You are sealing all of our fates."

Wedding can ignore no longer, and with quiet reply, "My mother says this is good for the family. Mother says I am to be..." Great Mother's tired eyes start to shine with the most life they've had in ever, "Girl, where is your Mama now? Where has she gone? How did piety and purity work out for her? What did it do for any of us?"

Wedding looks down to continue as if speaking answers to a catechism, "I will surrender. I am de-..."

"Devout," Great Mother says laughing and while wiping blood from her cheek, "Girl, you wanna see where devout will getcha? Do ya'? DO..."

"I'm devout" Victory smiles with worship in her vocal cords looking over at Great Mother and Wedding hoping to toss them her cheer. "Why, if you are devout, you take out a loan. You buy, buy, buy. In the name of our…"

"Girl? Child?" Great Mother turns to Wedding laughing hysterically, "Wanna be like her? Lookit where devotion will get you. In a slip, all tarted up thanks to…"

Victory draws a deep breath, "Yes, devotion. I serve. I do this for my country. Proudly." Great Mother looks at Victory and Wedding and looks down at the soldier they've had her cradling so long she forgets she is holding him and speaks quietly as if to herself,

I hold a man as if he is a child, I've been holding him for longer than I've lived. No one sees the tired in my eyes, no one looks closer to see where the blood has gone (aren't I supposed to be serving in the war?)

If I held him a little lower down, I'd be breastfeeding a grown man

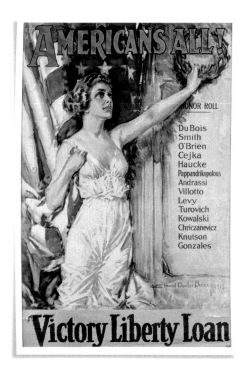

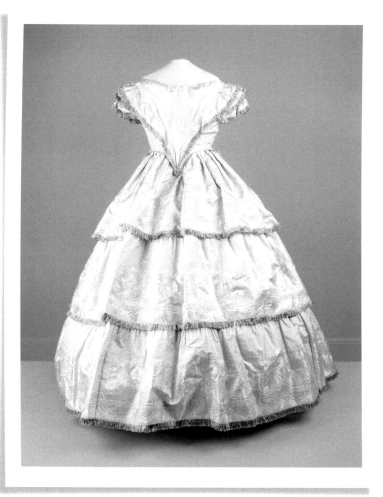

Me and him trapped by that cross, these angles that took the S curve out of the vernacular of my hips. Trapped by all the white, where is all of the blood that runs and runs and runs?

That cross…it is red, thick, maybe it takes all the blood. All the better to make sure we see. Don't you see…This is my duty, our duty until they decide we need to be repositioned. Until they decide Greatest no longer goes before my name.

Until they decide that you Wedding, will not be rewarded for your virtue, your doing, your being. Until they decide that you, Victory, will need to show a little more skin to show how loyal, maybe turn you frontal, maybe add more Rouge

They took my Rouge and gave it to the cross. Did I have children? Family? If I am the first Mary, which of you will be the other one?

In A So-Called Paradise with She-Who-Refuses-To-Be-Named

"To have one's dark body penetrated by the white gaze and then to have that body returned as distorted is a powerfully violating experience."

-George Yancy, *Black Bodies, White Gazes: The Continuing Significance of Race in America*, 2016

"But the seventeen-year-old girl does not wish to marry—not yet. It is better to live as a girl with no responsibility, and a rich variety of experience. This is the best period of her life."

-Margaret Mead, *Coming of Age in Samoa : A Psychological Study of Primitive Youth for Western Civilisation*, 1928

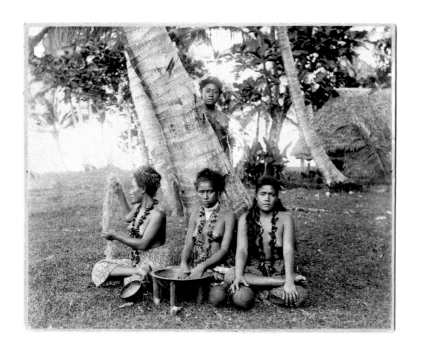

I refuse you to give us our names

I refuse you to say what you know. I know the house in the background like I know the man holding this camera the same way my sisters knew those garments the same way we knew to look...like this

At least you sat outside, in sun. Look, look, we wear their clothing. Look, look how we can show them now.

I give you noticing and leave you reckoning

Notice the way we stare,
we refuse you the dignity of connection
Notice the way some of us slightly slouch,
we refuse you the respect of straightened spines
Notice the direct gaze that threatens, that blooms
the uncomfortable
We refuse you paradise through our mouths
We refuse enigmatic smiles. We are no one's Mona.

Notice that we are always available

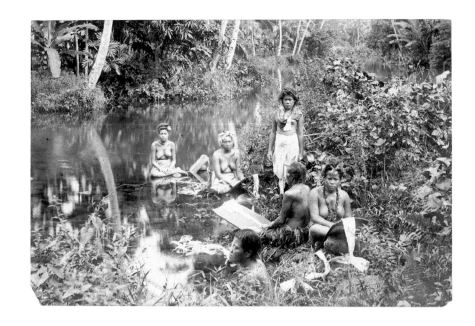

*You think you're available? We are available to be
posed as the dolls of their exotic erotic imagining.
We become the image of their women while
they salivate about the vision of what could be*

with breasts that refuse perky,
perky implies your happy
Available with no coupling, with no families,
not mothered nor mothering
Always bended into lotus legs

Your albumen concubines. Ready. Frozen. Hostage

In the House of the Golden Lotus: Bound Slipper Speaks to High Heeled Shoes (and You)

"Goddesses are the 'women' of the divine world and behave much as women are expected to behave. They are not role models that women devised for themselves, nor are they purely female self-perceptions, for the mythic images of goddesses-as-women had to make sense to the men who were reading and teaching the texts."

-Tikva Frymer-Kensky, *In the Wake of the Goddess: Women, Culture, and the Biblical Transformation of Pagan Myth*, 1993

That's how it started. Some man but not just some man, the Emperor. He whose gaze became enamored with how small parts of my body could become as I contorted, folded and shrink and shrink and shrink. Before you judge, it guaranteed position. Before you judge, see the small waist of the Victorian or this...

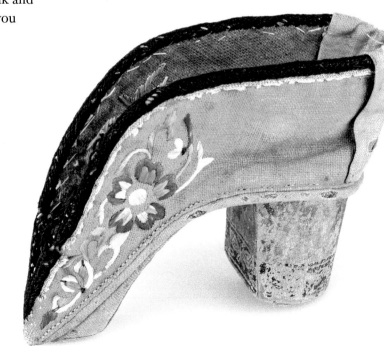

No, you have that wrong and I will have my say. Bound I am yes, to a smear job. Bound I am by all the tongues of men who claimed I caused hysteria and fainting. Their tongues training yet more tongues to claim what I did, how I did it, how I continue to do it ad infinitum.

I am one of many ripples as it is I who was used to launch ships into time's war against women's bodies. I am but an arrow used to find a target that became what tongues repeated to their children and their children's children. The tale told in classrooms.
I am the Mary Magdalene of fashion
The Patron-Saint-In-Broad-Day-Light-Of-Misunderstood
but, Bound, continue, as you were...

You may be a modern heel, but you're no different. See the stiletto. See the bodies and bodies and bodies of girls, of women handed over to deities. Gifted to marriage, to husbands. Our bodies, imprinted with devotion, elevated to sacrifice. And didn't we all think we were called to a purpose higher than ourselves?

You're no different.

I can feel the way you imagine how the rest of me balances on my 3-inch golden lotuses. I can see your eyes unable to look away, imagining that me within all of this is the victim within the barbaric. And yes, I danced. I may have danced for my Emperor to stay his favorite...

but you, who do you dance for?

Who do you become bound for?

Who do you make yourself small for?

Mende Sowei Mask

I am of the place where my being was luminous,
how did I learn to speak apocalypse?

I am named and I am known,
I am unnamed and among the missing

I am She-Who-Is-And-She-Who-Isn't
Only when you break and pull and break and twist
and pierce your tongue delirious maybe you can say me

If my name may be publicly spoken in my community,
how can I be named or spoken among the lost?

I am of the place where it is I who settles the disputes,
I punish, I....

what is punishment if one was never stolen but given, sold?
If I am named and my name is secret, then what will you know of me?

If I am my secret name and my secret name is known only to the few long from
here, am I doomed in the amniotic sac of amnesiacs?

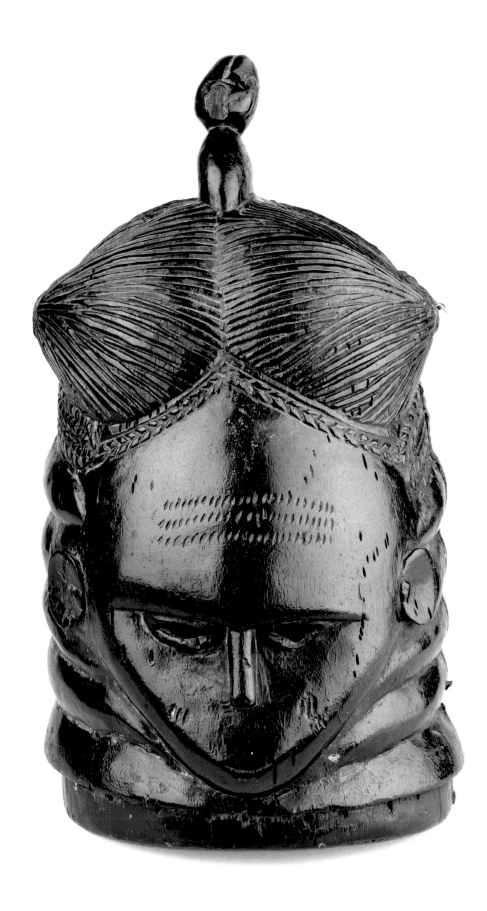

A Geisha Who Never Was:
Kimono Speaks

If museums are contact zones, what about bodies?
Can my body be the contact zone?
Is my missing body a contact zone for the way you...

...can't imagine that I had other lives.
...form the braille within your brain that this reads as dominated.
Servant. Fantasy.
...imagine that the body that has lived inside this garment can only be a Geisha.

I am the living object and subject.
I am art. I am culture.

I am my own.

The body molded and shaped and bound to your imagination?
That was never mines.

Mummy Fever

A mortar pestled skull to dull a head's ache,
King's drops with wine or chocolate,
mommy's helper turned mummy fever

-Excerpt from *Black Metamorphoses* by Shanta Lee

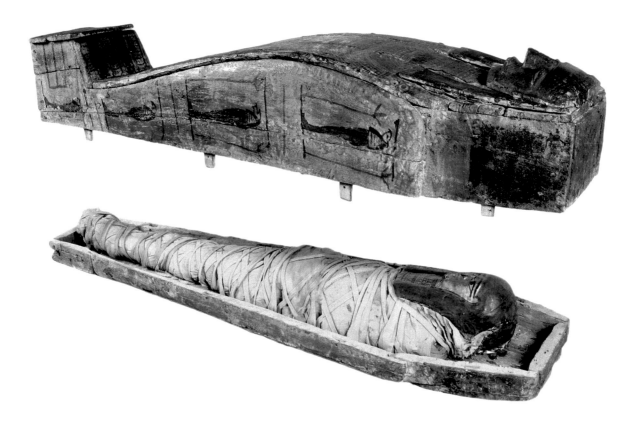

Powdered Mummy. To cure the epilepsy. To cure vertigo.

Balsam of Mummy. Only an Arabian in pieces will do. First soak in turpentine. First soak in wine. Tincture or Extract or treacle or elixir, or maybe mellified. And if mollified, start a steady diet of honey now then die then age 100 years.

There is no end to how you will continue to consume me.

Queen Mother Speaks

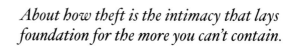

*If what is spoken is blessing or curse,
what if there was no choice of a contracted utterance.*

You don't know about such things

*I was stolen and sold and sold and sold and sold then
gifted as bride, and my value goes beyond the imagined.*

You don't know about such things

*About how theft is the intimacy that lays
foundation for the more you can't contain.*

*About how you tried to Christian me as the
Lack to your Plenty in the ways you chased
and chased and caught and...*

Texts that Inspired

The following is a list of texts that inspired and informed this quasi-fiction.

THE CONVERSATION

• This source is one of many in providing a short history on the Liberty Loans: Ohio History Connection. "Liberty Loans." Accessed January 10, 2022. https://www.ohiohistorycentral.org/w/Liberty_Loans.

• Pritzker Military Museum & Library. "Americans all!: Victory Liberty Loan." Accessed January 10, 2022. https://www.pritzkermilitary.org/explore/museum/past-exhibits/lest-we-forget-dough-boys-sammies and-sailors-great-war/victory-liberty-loan.

• Gilman, Charlotte Perkins. "The Yellow Wallpaper." *The New England Magazine* V (January 1892): 647-656. https://www.nlm.nih.gov/exhibition/theliteratureofprescription/exhibitionAssets/digitalDocs/The Yellow-Wall-Paper.pdf.

• Baring, Anne and Jules Casford. *The Myth of The Goddess: Evolution of an Image*. New York: Penguin, 1993.

• The original text of the "Thunder" poem was discovered with the Gnostic manuscripts in 1945 and are dated to some time before 350 C.E. Taussig, Hal, Jared Calaway, Maia Kotrosits, Celene Lillie, and Justin Lasser. *The Thunder: Perfect Mind: A New Translation and Introduction*. New York: Palgrave Macmillan, 2010.

IN A SO-CALLED PARADISE WITH SHE-WHO-REFUSES-TO-BE-NAMED

Information about John Davis and the photographs have been provided by the Fleming Museum's curator, Andrea Rosen. The *New York Times* article is one of the pieces shared during our exchange. That article along with the following was inspiration for this section:

• Mead, Margaret. C*oming of Age in Samoa: A Psychological Study of Primitive Youth for Western Civilisation*. London: Forgotten Books, 2016.

• Tcherkézoff, Serge. *'First Contacts' in Polynesia: The Samoan Case (1722-1848): Western Misunderstandings about Sexuality and Divinity*. Australia: The Australian National University E Press, 2008.

• Yancy, George. *Black Bodies, White Gazes: The Continuing Significance of Race in America*. Lanham, MD: Rowman & Littlefield, 2017.

• Boxer, Sarah. "Photography Review: Mythological Images of a Lost Samoa." *New York Times*, March 29, 1996. https://www.nytimes.com/1996/03/29/arts/photography-review-mythological-images-of-a-lost-samoa.html.

• Cole, Teju. "When the Camera Was a Weapon of Imperialism. (And When It Still Is.)." *New York Times*, February 6, 2019. https://www.nytimes.com/2019/02/06/magazine/when-the-camera-was-a-weapon-of imperialism-and-when-it-still-is.html.

In the House of the Golden Lotus: Bound Slipper Speaks to High Heeled Shoes (and You)

There are a range of legends about foot binding including a variation that I wrote in the "voice" of the item. There are other sources, included below, that link the start of feet binding to the fact that the favorite concubine of an emperor was born with a club foot.

• Szczepanski, Kallie. "The History of Food Binding in China." *ThoughtCo.* Updated November 21, 2019. https://www.thoughtco.com/the-history-of-foot-binding-in-china-195228.

• Cartwright, Mark. "Food-Binding." *World History Encyclopedia*. Published September 27, 2017. https://www.worldhistory.org/Foot-Binding/.

• Frymer-Kensky, Tikva Simone. *In the Wake of the Goddesses: Women, Culture, and the Biblical Transformation of Pagan Myth*. New York: Fawcett Columbine, 1993.

Mende Sowei Mask

Inspired by materials within the Fleming Museum of Art's files for this artifact. I was also struck by this naming ceremony featured on the YouTube page of The British Museum: "Sowei Mask: Spirit of Sierra Leone." Last modified March 1, 2013. https://youtu.be/jW8-Ni-MeN4.

A Geisha Who Never Was: Kimono Speaks

Inspired by my initial inquiry and exchanges with Fleming Museum of Art curator, Andrea Rosen, along with the following sources:

• Pound, Cath. "Kimono: from status symbol to high fashion." *BBC*. March 11, 2020. https://www.bbc.com/culture/article/20200305-the-japanese-kimono-status-symbol-to-high-fashion.

• Kincaid, Chris. "Kimono in a Mono Cultural World." *Japan Powered*. January 19, 2014. https://www.japanpowered.com/japan-culture/kimono-in-a-mono-cultural-world

• Hodge, Sarah B. "10 Things to Know About Kimono's History, Design and Evolving Future." *Tokyo Weekender*. July 5, 2019. https://www.tokyoweekender.com/2019/07/10-things-know-kimonos-history-design-evolving-future.

• Frank, Priscilla. "A Brief and Stunning Visual History of the Kimono: How the iconic Japonisme garment evolved from the 8th century to present day." *HuffPost*. April 4, 2016. https://www.huffpost.com/entry/a-brief-and-stunning-visual-history-of-the kimono_n_5702abbce4b0daf53af03e8b.

Mummy Fever

Inspired by materials within the Fleming Museum of Art's files for this artifact and the following sources:

• Lovejoy, Bess. "A Brief History of Medical Cannibalism: Curing what ails us with mummy, blood jam, and human fat." *Lapham's Quarterly*. November 7, 2016. https://www.laphamsquarterly.org/roundtable/brief-history-medical-cannibalism.

• Adeline, Jules. *Adeline's Art Dictionary: Containing A Complete Index Of All Terms Used In Art, Architecture, Heraldry, And Archaeology.* New York: D. Appleton and Co., *1905.* https://brittlebooks.library.illinois.edu/brittlebooks_open/Books2009-03/adelju0001adeart/adelju0001adeart.pdf. .

• Homan, Peter. "Using a mummy as a medicine." *The Pharmaceutical Journal.* April 8, 2015. https://www.pharmaceutical-journal.com/article/opinion/using-a-mummy-as-a-medicine.

QUEEN MOTHER SPEAKS

Inspired by materials within the Fleming Museum of Art's files for this artifact and the following sources:

• Wills, Matthew. "The Benin Bronzes and the Cultural History of Museums." *JStor Daily.* May 22, 2021. https://daily.jstor.org/the-benin-bronzes-and-the-cultural-history-of-museums/.

• V & A. "Tony Phillips on the History of the Benin Bronzes I-XII." https://www.vam.ac.uk/articles/tony-phillips-benin-bronzes#slideshow=34561552&slide=0.

• Al Jazeera English. "The Stream: Who owns the Benin Bronzes?" Streamed live April 28, 2021. Video, 25:35. https://www.youtube.com/watch?v=nVIGa6RwEo8.

• The Open University. "Art, Loot and Empire: The Benin Bronzes." Last modified February 19, 2021. Video, 28:07. https://www.youtube.com/watch?v=YJIkhMi_6PU.

FLEMING MUSEUM OBJECTS ILLUSTRATED IN "OBJECT–DEFIED"

For objects included in the exhibition, their full information is given in the *Works in the Exhibition* list on pages 76 to 78. Other works are given full details here.

THE CONVERSATION

PAGE 34: Alonzo Earl Foringer, *The Greatest Mother in the World*, about 1918

PAGE 35: Howard Chandler Christy, *Americans All!*, 1919

Unknown artist (United States), *Wedding Dress*, 1857

IN A SO-CALLED PARADISE WITH SHE-WHO-REFUSES-TO-BE-NAMED

PAGE 36: John Davis, *Women Making Kava*, about 1892

IN THE HOUSE OF THE GOLDEN LOTUS: BOUND SLIPPER SPEAKS TO HIGH HEELED SHOES (AND YOU)

MENDE SOWEI MASK

A GEISHA WHO NEVER WAS: KIMONO SPEAKS

MUMMY FEVER

QUEEN MOTHER SPEAKS

Essays

Seeing and Unseeing the Dark Goddess: Shanta Lee Gander's Oppositional Gaze

by VICKI BRENNAN

"Looking and looking back, black women involve ourselves in a process whereby we see our history as counter-memory, using it as a way to know the present and invent the future."

--bell hooks, "The Oppositional Gaze"

"So many of the Dark Goddesses... are the ones we call upon for justice and strength in the face of victimhood. And the Dark Goddess is so much of that strength of that, 'You are not going to eff with me. I'm a bad bitch.'"

-From Shanta Lee Gander's interview with Heather

In *Dark Goddess*, Shanta Lee Gander brings together text, image, and artifact in order to reframe how raced and gendered bodies are encountered by museum audiences. In this vibrant, multifaceted exhibition, photography, writing, and curation become tools for constructing liberatory practices of seeing and being seen, and for exposing racist and misogynistic assumptions embedded in museum conventions of collection and display.

Gander explores the underside of the goddess concept, both referring to and pushing against more conventional anthropological and (white) feminist tropes about "the sacred feminine." Her exploration of the powerful, potentially destructive side of the sacred feminine in this collection of photographs certainly harkens back to feminist art and writing of the 1970s and '80s. Goddess feminists centered female experiences and bodies in their artistic practices and cultural productions, striving to imagine into being a mode of existence that emphasized female power and feminist spirituality. This included a range of approaches and knowledge systems, including archaeological findings such as those of Marija Giumbutas, who argued for the existence of prehistoric matrifocal cultures in which goddess figures were revered and worshiped; radical feminist theologies such as that of Mary Daly, who called for a rejection of patriarchal religious systems and the embrace of a cosmic sacred feminine consciousness; and artists such as Mary Beth Edelson and Barbara T. Smith, along with the poets Adrienne Rich and Audre Lorde (among others) whose works exemplify female power and feminine divinity. [1]

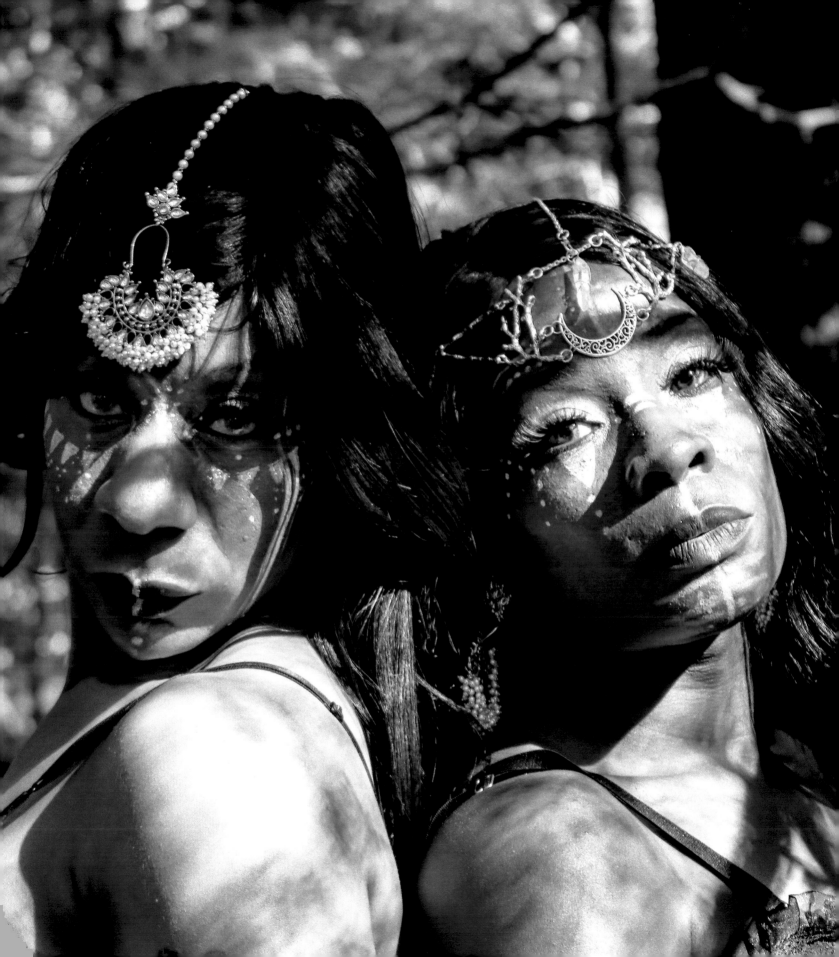

However, even in its time the feminist goddess movement was haunted by its lack of inclusivity and its blindness to how racist assumptions were written into its practices. As Audre Lorde famously wrote in a letter to Mary Daly concerning her neglect of Black goddesses and her treatment of Black women only as victims or oppressors in *Gyn/Ecology:* "To imply, however, that all women suffer the same oppression simply because we are women is to lose sight of the many varied tools of patriarchy. It is to ignore how those tools are used by women without awareness against each other."[2] In a related vein, artists such as Betye Saar rejected the ideal of the sacred feminine articulated by white feminists, by refusing to aestheticize the body and instead—as in her reimagining of the stereotyped "mammy" image of Aunt Jemima as a warrior figure—pointing to the ongoing racist and sexist assumptions embedded in American visions of Black women.[3]

In returning to these themes almost 50 years later, Gander repositions the depiction of the sacred feminine in relation to more recent Black feminist art and thought. Drawing on what bell hooks has described as an "oppositional gaze"[4] and what Tina Campt has discussed as "a Black gaze that shifts the optics of 'looking at' to a politics of looking with, through, and alongside another,"[5] in Gander's work the representational mode shifts and looking becomes a site of both resistance and opposition. Gander frames the "Dark Goddesses" of this exhibition through her camera lens to acknowledge the desires of the women depicted to see and be seen. "This isn't anything you will be able to unsee," the label for *DARK APHRODITE* warns. Look if you dare—but maybe you shouldn't.

Gander's work also extends the tradition of Black artists who take up themes and images connected to African diasporic religious traditions and spirituality. Goddesses such as Erzulie, Ošun, Yemanja, Oya, and others are frequently portrayed in a variety of iconographic media by religious practitioners of Haitian Vodou, Yoruba Orǐsa, Brazilian Candomblé, and Cuban Lucumí.[6] These depictions of the feminine sacred are central to religious worship in these traditions. A variety of contemporary artists have drawn on such visual representations of African goddesses, ranging from those associated with the Ošogbo School's "New Sacred Arts" movement who created paintings, prints, and sculptures inspired by Yoruba mythology, to Beyoncé's recent invocation of Ošun and other Black Atlantic deities in her visual albums *Lemonade* and *Black is King*.[7] In these creative elaborations of Black Atlantic goddesses artists present a politics of liberation that points towards a reclamation of African culture in the face of imperialism.

Rather than focus solely on the goddesses of the African diaspora however, *Dark Goddess* reimagines goddesses from across religious traditions and cultural heritages, ranging from Christianity, Irish folklore, and Greek mythology, as well as from hybrid mixtures of these practices. The only explicit reference to Black Atlantic religions is evoked in the Obeah series of photos, whose title implies a connection to Jamaican spiritual practices of healing and protection. While women who engage in Obeah are often depicted in colonial archives and popular culture as witches harnessing potentially evil powers (as in the *Pirates of the Caribbean*

Heather as *EVE*, in photograph not included in the present exhibition. Courtesy of the artist.

movie franchise for example), Gander and the models depicted in the photographs reject such an interpretation, instead focusing on how they can use their bodies in space to depict a sense of power and energy. In her interview with Gander, Kahywanda insists that her Obeah pose is not about the occult, but rather is about positivity, nature, and being "at home."

Gander's work with her camera and the models in the photographs featured in this exhibition remix a conventional understanding of what is sacred about femininity, and invokes a critical sensibility derived from Black feminist thought that moves beyond the romantic and essentialist imaginings of earlier goddess feminists. Gander re-envisions Aphrodite, Hecate, and yes, even the Biblical Eve, through the lens of her camera, as these goddesses are seen through her oppositional gaze, summoning what the theorist bell hooks described as an invocation of history as counter-memory (see epigraph to this essay).

This practice of "looking and looking back" is also central to "Object-Defied," a curated selection of objects from the Fleming Museum's collection that Gander has assembled to accompany her photographs. A wedding dress worn by a Vermont bride, a wooden mask worn by an initiate in Sierra Leone, a shoe from China to be worn by a woman with a bound foot are made to speak "with, through, and alongside" one another and the portraits of the Dark Goddesses. Gander's labels bring a critical voice to objects from the archive that have typically stood for a variety of things, especially when displayed in the art museum: a mapping of

civilizations according to hierarchies of white supremacy and a triumphalist documentation of colonial extraction, among other discourses. In contrast, Gander's poetic and evocative texts serve as a stark rejoinder to the museum's bare bones description of the object at the bottom of the label, typically referred to as the object's "tombstone." In opposition to this curatorial pronouncement of their death, the re-animated objects speak, providing a counter-narrative of histories of racist and misogynist subjugation, and pointing to the historical practices that have presumably transformed them into mute representations of aesthetic styles, historical periods, or cultural practices.

Just as the photographs of the Dark Goddesses invoke a knowing awareness of how the images will be seen and possibly misinterpreted, the labels in "Object-Defied" also point to an acknowledgement of the institutions and modes of authority that provide access to the objects in the first place. Gander's texts recognize the power structure that allows collectors, curators, and artists to excavate the materials of the past to say something about the present. There is a critical acknowledgement of what it means to claim ownership or to venture an interpretation. "There is no end to how you will continue to consume me" the unknown mummified man says through Gander's label, implicating viewers of this exhibition in these processes.

[1] See Jennie Klein, "Goddess: Feminist Art and Spirituality in the 1970s," *Feminist Studies* 35, no. 3 (2009): 575-602 for more background on this artistic movement.

[2] Audre Lorde, "An Open Letter to Mary Daly," 1979, *History is a Weapon*, accessed January 18, 2022, https://www.historyisaweapon.com/defcon1/lordeopenlettertomarydaly.html. I am grateful to Drs. Megan Goodwin and Ilyse Morgenstein-Fuerst for drawing my attention to this exchange.

[3] For more on Betye Saar's work see her website: http://www.betyesaar.net/index.html. I am grateful to Marina Peterson for bringing Saar's work to my attention.

[4] bell hooks, "The Oppositional Gaze: Black Female Spectators," in *Black Looks: Race and Representation* (Boston: South End Press, 1992), 115-131.

[5] Tina Campt, *A Black Gaze: Artists Changing How We See* (Cambridge, MA: The MIT Press, 2021), 8.

[6] The Fleming Museum featured objects connected to Black Atlantic religions, including iconography related to Black Atlantic goddesses in the "Spirited Things: Sacred Arts of the Black Atlantic" exhibition in 2017.

[7] For more on the Osogbo School/New Sacred Arts Movement see Peter Probst, *Osogbo and the Arts of Heritage* (Bloomington: Indiana University Press, 2011). For more on Beyoncé's use of African diasporic religions in her visual albums see Kinitra D. Brooks and Kameelah L. Martin, *The Lemonade Reader* (New York: Routledge, 2019) and Taylor Crumpton, "Glory B: Beyoncé, the African Diaspora, and the Baptism of 'Black is King,'" *The Ringer*, August 4, 2020, https://www.theringer.com/movies/2020/8/4/21353713/beyonce-black-is-king-african-diaspora-orisa-oshun.

Seeing and Being Seen by the Dark Goddess

by EMILY BERNARD

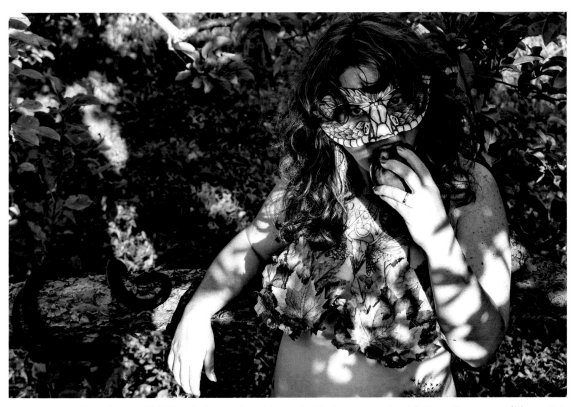

Heather as *EVE*, in photograph not included in the present exhibition. Courtesy of the artist.

"Ain't I a woman?" Sojourner Truth asked this question in 1851 at the Women's Convention in Akron. Of all the brilliant words in her speech, the weightiest is "I." It resounds with the hunger and ambition of every woman who ever wanted to say it, to claim a stage, but was forbidden, and every woman who dared to say it anyway. *I*. How dare you.

Saying *I* is a way of laying claim, both to language and to spaces that language occupies. Language lives everywhere. Saying *I* is an act of power. What happens when women lay claim to their power? In *Dark Goddess*, women—on the page, on either side of the camera's lens—confront all possible outcomes. No one is immune to the seductions of power, and *Dark Goddess* puts forth no false narratives about inherent female innocence or goodness. In this exhibition, power is thorny, sweet, beautiful, and raw. The same force can liberate or destroy you; it is thrilling and intoxicating; joyful and terrifying. *Dark Goddess* denies nothing about the power of power.

As I made my first journey through this exhibition, I understood immediately that I was in the presence of something I had never seen before. At the same time, it was utterly familiar to me. All these images and stories I *had* seen before; they are records of human fears

and fantasies, codified in fairy tales and legends. In the world that Shanta Lee has created, Eve looks us dead in the eye while she bites into an apple. Women regard us openly from wherever they stand in the natural world. There are no demure glances under dropped lids, no masks designed to entice and mollify men. In *Dark Goddess*, women lean back and let the world itself support them while they watch those who watch them. In *Dark Goddess*, no one tells a woman to smile.

I was delighted. I was intrigued. And I was afraid. Isn't Eve the mother of shame? I looked for the shame in her eyes, the same shame she passed down to me and all her other daughters. It was only when I saw the absence of that shame in the eyes of Eve and all the other women of *Dark Goddess* that I realized that shame was a lie.

Or maybe not a lie, but certainly just a story, a story no more powerful than the one Gander has imagined for us. But fear is almost always a lie, a cover for things we don't understand. The images and languages herein are meant to set loose a tremor of something inside us. You can call it fear. I call it curiosity.

"What was it like to be seen by me?" Shanta Lee asked the goddesses in this exhibition. She might ask the same question of her readers and watchers. What was it like for me? I was afraid, and then I was interested. I let my curiosity lead me down the trail you left for me. The trail took me deep into some woods I'd never seen, woods I knew as well as I knew my own skin. I knew them from my dreams and nightmares. I opened my eyes and saw that both dreams and nightmares are only stories, so I kept going. I dared.

Your trail took me to some abandoned train tracks, where I lingered, and listened, and learned. Along the trail, I was offered both fruit and knives to taste, and I tasted both. It was only by tasting both that I learned the distinction between what is sacred and what is profane resides in language, in point of view. Along the trail I met women and goddesses and I understood they were the same, that the difference depends on us, on how far we're willing to go. It was only by following the trail and its many tributaries that I realized how far I was willing to go for the sake of my curiosity. No matter my pace along the trail you left for me, no matter which tributary I pursued along the way, it all brought me to the same place—this hidden universe of women, dark goddesses. What was it like to be seen by you? It made it possible for me to see myself.

Thank you, Shanta Lee for the vision, the invitation, the dare.

Q & A

Q & A

A Conversation Between ALICE BOONE and SHANTA LEE GANDER

What does Dark Goddess mean for you in this project? How has the meaning changed for you over its many forms?

It's funny, I've been thinking a lot about Millie Jackson. I grew up listening to everybody from Mahalia Jackson, the gospel singer, to Millie Jackson, the blues singer, who would put everything from bedroom to boardroom, to everything in between out on front street. When I first thought of this project, Millie Jackson came to mind because she represents what someone might call the obscene, or the raw. However, I see her as one of many examples of the power of what it means to be a woman. About seven years ago when I said I wanted to explore the Dark Goddess, I was initially thinking: What's the opposite of the overuse of the Greek pantheon of gods and goddesses?

Initially, I was thinking on the level of the sacred, She-Who's-Higher-Than-Mortal. But what's the other side of that pantheon of the sacred? All of these collaborations–the women featured in the exhibition, and how they chose their own images–clarified this concept for me. Millie Jackson then becomes some kind of Dark Goddess in terms of her conjuring with words, and the way she talks about things on an open stage, in open public, that one usually didn't talk about. The Dark Goddess energy of Eartha Kitt as she answers a question during an interview, followed by wild laughter when she says, "A man comes into my life and I have to compromise? You better think about that one again." I've been catching glimpses of the Dark Goddess who misbehaves since I was a little girl.

She is also not just the reified or deified. She is your everyday mama. Maybe she's your born mama or chosen mama... or all these different manifestations of the whole of womanity from sacred to profane.

One of the things that seems to drive your work is the dialectic. That is the sense of two opposites that can't fundamentally compromise. They push and pull at each other, but they create this heat and this friction, and the friction is actually what drives the ideas forward and actually gives them a shape.

I'm going to tell you something that flipped my wig, it was sort of like, "Whoa!" I've been thinking about my approach to creating the alternative titles for the artifacts that are in the Fleming Museum of Art's collection. I wanted to do something that flipped what people were seeing. As I was thinking about the corset and I was searching for some of the things or complaints that women might have written about the messed up experience of wearing a corset. As I was exploring, I came across Valerie Steele's book, *The Corset: A Cultural History*.

I'd also been thinking about the kimono too, because I'd just asked Andrea, "Do you have any kimonos that were worn by geishas?" All of this is ironic given that I am exploring the model of the prison, the prison of the mind, and perception via the panopticon. Yet, I was driven by being so enthralled with the figure of the geisha, which led to the question I asked about the museum's collection. Andrea shares, "No, we have some that were used in marriage or by women in Samurai or Shogun families." As I did more reading and sat with this, I realized that I put the corset and the kimono in a prison of my own perceptions about what purposes both garments served in separate cultures, for whom, etc. And with the corset, it was interesting because despite my continued misinformation, I'd been wearing corsets for years as a fashion statement, collecting them. Something inside me must have known that there was some BS up with the overall bad rap on them though I still held to this horrible image of the Victorian woman having her insides squeezed by her corset. For this exhibition, I allowed myself to clash on the page, and challenge these misperceptions. So even in the artifacts themselves and the deeper exploration and thinking, and then having to turn the light on myself and think about, yes, I own a book called *American Geisha* because of the amazing work of the artist Olivia De Bernardinis who did these stunning paintings of women. What does that mean, and what kinds of questions arise from that kind of self-questioning? In other words, did misinformation and my perception collude in creating a continuous picture of the kimono and the corset as they relate to women's bodies?

So you're interested, then, in always sort of questioning yourself and you find these objects that actually break open those questions for you. And I love that you're making the objects talk, too. It seems like you're always sort of thinking about, again, that kind of back and forth or push and pull between all the different collaborators, whether they're objects or people in a project.

Yes, yes.

It seems like collaboration is a big driver of your work. How did the project evolve with different models, their choices, the relationships that you built with them in front of the camera and beyond?

Oh, that's a good one.

Even with the process, though I thought about it seven years ago, this project was initiated with an exchange with Caighla. Caighla and I always talked about working together again and last year, we made a plan to do a photoshoot. We were still in the middle of the pandemic and I hadn't picked up my camera. I hadn't been to an abandoned place. I felt like my wings were clipped though I still kept writing.

I wasn't thinking about the Dark Goddess during our shoot. After I got home, maybe a few days or a week passed, I started looking at the photos from that day with Caighla. Then I realized I was staring at the Dark Goddess. She jumped out through the screen. Caighla and

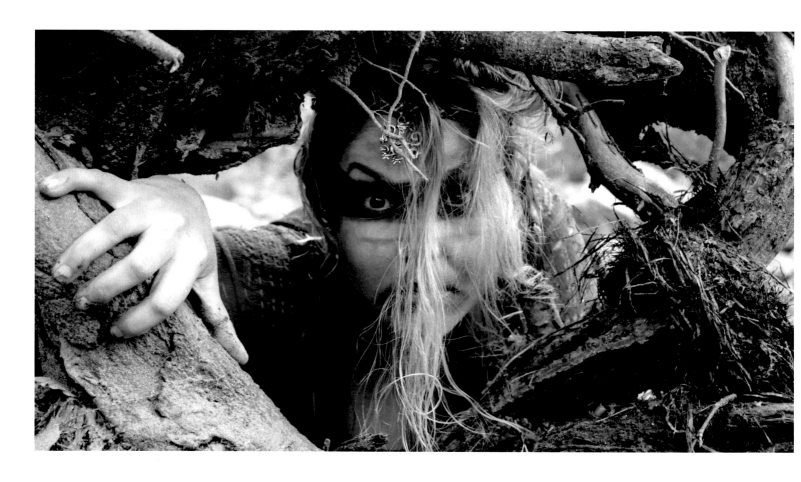

ABOVE: Not displayed in the current exhibition, this photograph was a part of the *Dark Goddess* exhibition shown at the Southern Vermont Arts Center in Manchester, VT during the fall of 2021.

LEFT: Not displayed in the current exhibition, this photograph was part of the *Dark Goddess* exhibition shown at the Southern Vermont Arts Center in Manchester, VT during the fall of 2021.

I hadn't discussed it, so I circled back around to seek the proper permission. From then on, I remember posting about it. I remember people coming forward saying they wanted to do it. I remember also talking to a few friends in different states saying, would you be interested?

The process with each person took, on average, a month. Sometimes a little longer. There are other individuals I want to collaborate with in my exploration of Dark Goddess concepts as I continue to grow this body of work.

It was all an ongoing exchange and conversation: checking to see what each individual wanted to be, how they wanted their image to be represented. In most instances, the individuals chose their personas. However, I had a slightly different approach with Alyse and Kahywanda, I've known them since I was 13 years old. As children (and as adults), Alyse and Kahywanda would speak Pig Latin to each other while the rest of us had no clue what they were talking about. I thought about their bond and how cool it could be to have them photographed, together, as Dark Goddesses, but linked to the Jamaican supernatural concept of the Obeah.

The planning also included asking individuals to think about what the concept of the Dark Goddess means to them. How did they want to embody that? The work is still in process and it continues to evolve.

I love that. It makes me think about the question that resonates in so many of your interviews, which is you asked the collaborators, what was it like to be seen by me? What has been the most surprising answer that you've received? What have been answers that have shifted how you see your own position as a photographer?

Yeah. For example, I was not prepared for how Heather (Eve in the exhibition), talked about her upbringing that was strongly Christian around the time she was entering adolescence. And what she did with Eve in terms of an attempt at disruption, she took it and made it her own. Heather also talked about her choice in becoming a mother—she was pregnant during the shoot—and shared her conscious choice to model as a way to challenge her body dysmorphia.

Another instance was talking to Kahywanda and the surprise when she told me that this felt like an accomplishment for her and her cousin because they are both cancer survivors. I know them intimately and of course knew about their cancer journey. However, I underestimated how Dark Goddess would bridge to such intimate stories and sharing in the ways that many saw themselves.

That may sound trite, but this was a huge lesson especially as someone who regularly ventures into abandoned places, there's something about the way that you trespass. Even technically you probably shouldn't be trespassing because it assumes that places are non-sentient. They're sentient. With bodies, people, they are living and breathing, why don't we give that same description or thought to artifacts?

Working with these individuals illuminated or reminded me that there is this responsibility with the power that involves a very complicated technology, the camera, that was wielded within imperialism and colonialism, that maintained a certain power over how people see themselves. It's a complicated inheritance. I get to challenge it and shift it in conscious ways. I am not just responsible, I am beholden to something that is beyond myself. Something that must be treated with care, must be engaged with care. I hope that I am opening a door for people to see beyond what they think they're seeing and question themselves.

It's a complicated inheritance. I get to challenge it and shift it in conscious ways. I am not just responsible, I am beholden to something that is beyond myself.

That word care, curator, it has care embedded in it.

Yes.

Many of the conversations that I think curators are having right now revolve around this idea: how is that care sometimes also a mode of control?

Yes.

Or of gate-keeping.

Yes.

It makes me think about the ways that we could throw that into the dialectic of the sacred feminine, and come up with other modes of care that are not solely controlling. So how does the sacred feminine kind of give us new ways of thinking about care?

It forces us to rethink language and how we use it. What does it mean for something to be sacred? Because if something that is sacred can be stolen, is it no longer sacred? Or how do we think about erasing the line between sacred and profane? We refer to the planet as Great Mother but look what we've done in a great mother's house. Also, if the planet is our Great Mother, then we are putting something up here and then putting something down there. I would say that care involves questioning things like using language to create this power dynamic, even if we run the risk of making ourselves uncomfortable, even if we run the risk of having to admit we were wrong about how we thought of something or a situation, or perceptions.

The care also involves taking a risk to disrupt. Care doesn't necessarily mean that it's going to be very cushy and comfortable. It means that something's opening. Something is going to be shaken up, but it's out of the care that it gets

shaken up because you want to see something on the other side that you're not seeing now. It makes me think a lot about the ways that specifically feminine care is often about watching something transform and in some ways ceding power, in order for things to find their own power.

Also thinking about the sharing of power or how do we rethink or redefine what that power is? Cause I don't think power is all bad, especially if you're in a body that has often been disempowered, or has presented as disempowered, there's a way that power could become the drug you seek. Speaking for myself, I think about the concept of objectification and challenging what it means. For me, it is about taking power back. The objectified is not necessarily powerless.

It also seems like change and metamorphosis are constant themes in the sacred feminine, because transformation is what activates those manifestations of it. Your second book of poetry is set to be published next year, and I wondered how the subject matter of _Black Metamorphoses_ is linked to these photographs. Are there particular retellings of Ovid's _Metamorphoses_ that seem to illuminate your work in Dark Goddess?

So I want to say it was 2017, 2018? This is the Penguin Classics version translated by David Rayburn, you see my copy is all tagged up. It's about 600 pages. I knew about these stories, but I wanted to read it cover to cover. Also, I've been on a bent thinking about being a poet and revisiting different old texts, including the Bible.

I did not have Dark Goddess in my head at all, I was thinking straight poetry when I had a thought that I wanted to see what a _Black Metamorphoses_ would look like. The shape, shifting the transformation, the questioning of power dynamics that were clear between mortals and gods but then what about the power dynamics of race, positionality, history, and how would all of that be interpreted? When the work started to come out for _Dark Goddess_, and even in thinking about some of these artifacts, there are many things in common with _Black Metamorphoses_. Themes of hunger, especially in connection to desire. The power dynamics of one group wielding power over the rest of the world in terms of colonizing and taking. Reckoning with history and reclamation. And as I am saying that we overly rely on the Greek pantheon as a culture, someone could look at my forthcoming book and say, "Well, you did that." However, I did it to disrupt, interrogate, explore a range of other myths similar to the way I am exploring other goddesses within the world's pantheon. The book and exhibition encourage individuals to question what they see, what they think they're seeing, and how they are trained to see.

Also, a point about desire. In looking at desire in relation to the exhibition, I have been thinking about the artifacts in terms of a lust for the other. I have also been thinking about the exploration of the object as inactive or passive and realized that in many ways, the object becomes very active and engages the viewer. For instance, we tend to view the human subject within a photograph as potentially objectified. In the same way, an object that is not human

can be sentient in a way that inspires us to ask this question: What is it about them - the objectified - that wields a power over the viewer? Hence making the artifact or object active.

You have spent a lot of time with documents and archives from the Fleming Museum, some of which have huge gaps in them, some of which show a very kind of particular orientation to knowing ethnographic objects in a very narrow way. How is your photography transforming this sense of what a museum thinks of as the important information to organize and know the world of objects?

I have been thinking about this in so many ways. There are many levels of risk involved with organizing how the public sees. For example, there is a power in creating an alternative title; and an institution allowing an artist to do such a thing - like what has happened with *Dark Goddess* - is both risky and brave.

What is it about them - the objectified - that wields a power over the viewer? Hence making the artifact or object active.

I felt like I was caught between playing Adam in the Garden of Eden while thinking about the power of the Ursula K. Le Guin short story, "She Unnames Them." This is a story I was introduced to through the work of artist Kaylynn Sullivan TwoTrees in one of her recent exhibitions. To name a thing, or in this example, to put language to artifacts is both a power and responsibility. In some instances, I had to give thought to artifacts like the John Davis photos of the Samoan women and ask myself, "do I have the right to name them?" The photos seemed to say, "We're not giving you permission to name us. You don't get to do that."

This was trippy because usually artists are the ones handing their work over and they're in collaboration, but the institution has the power. Institutions are the ones creating the context for the work. This happens through labels that traditionally "explain" the object. This invites the artist to explore: where do I want to position my work, especially within a given space. For years, museums have been referenced as a contact zone, as the place where cultures and different things come together and sometimes clash.

Over time, we've forgotten some of these truths about the museum space especially because we, as viewers, even as artists who become viewers and consumers, go into these spaces and there's a way that we don't question. It is easy to forget how certain spaces, like museums, groom the human gaze. It becomes a situation where, because the institution is seen as authority, one is not going to question what's wrong with what is being seen or experienced. At least traditionally, one has gone into these spaces and accepted what is put on display or maybe you do that inquiry privately.

I remember once being in The Metropolitan Museum of Art and looking at this huge Ganesh, and I kept looking at the label that said "gift from…" I'm like, well, what was this family doing with this? This large Ganesh looked like a few of the sacred places I visited in India and it felt out of place. What were they, this family who donated this artifact, doing

with this such that they were able to gift it? I often revisit the conversations that have been taking place for years that engage with these and other tough questions. I want to contribute to those conversations in the ways that the artist Fred Wilson does in his work. I've long admired Wilson's work and how he goes in and disrupts space and recreates space in ways that challenge how we experience the museum space, and where certain bodies and things are, and what's in the archive. I want to bring that attention to the work, to the space, and to those who may come in contact with it.

I'm also a journalist who has done investigative journalism and I embody the idea of the inquiry that goes beneath the surface. In this and all of my other work, I encourage the audience to go beneath the surface such that it leaves us questioning and challenging ourselves. I envision the museum as a space that transitions from being static to being a flexible and permeable space. Another evolution in being a contact zone within a given community.

Perhaps this also means that much of this collection is shared with the public in a way that invites more of the conversations. This might invite a potential for the artifacts to rise above being the collected to becoming active participants within the conversation. Even in the way that the label, for me, is another space. It's a kitchen table, much like that presented in Carrie Mae Weems's foundational work in her *Kitchen Table* series. I would love to see museum spaces become like that space, an unzipping and bringing a certain level of the intimate into the very public. In the same way the blues singer, Millie Jackson, says, "If it comes up, it's coming out."

I wanted to think with you about how your work helps us re-see the panopticons in the architecture of the museum. Your photographs are going to be displayed on the balcony of the Marble Court , which is a space where there's this sort of constant implicit surveillance of behavior. You can hear everything that happens in that room. It echoes off the marble surfaces. The Marble Court itself is this aesthetic architectural fantasy of the Greek pantheon that you mentioned earlier, done in neo-classical white marble. People police themselves in that room, because it feels in some ways so sacred, but also so oppressive in some ways that all you can do is walk through silently. Then at the same time, we're also thinking a lot about how to reimagine our portrait gallery, which is this irregularly shaped center gallery that I often talk about with classes as a panopticon of whiteness, because it's been curated as these portraits of almost entirely white wealthy people, who are all kind of staring at you in the center of the room. Both of these spaces are these spaces of whiteness. But you've also talked about them as spaces where they're ripe for reclamation. How does that reclamation disrupt both the myth-making and the sense of the ethnographic panopticon that happens so often in museums, where it's just white people gazing at objects and then mediating them through a narrow idea of what it means to see other cultures?

Yeah, it's interesting because the panopticon took off in a very European male way. English philosopher, Jeremy Bentham, in the 1700s, built upon the idea of the panopticon based on

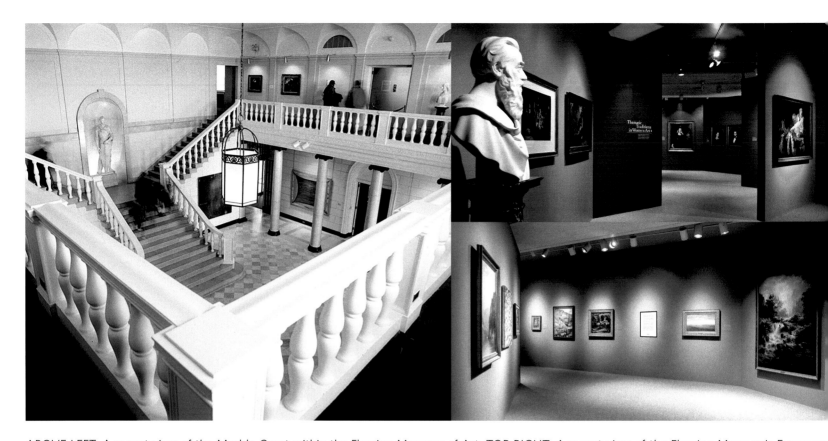

ABOVE LEFT: A recent view of the Marble Court within the Fleming Museum of Art. TOP RIGHT: A recent view of the Fleming Museum's European American gallery. BOTTOM RIGHT: A view of an "Absence" label replacing the print *Ship* by Edward Ruscha. As the "Absence" label describes, " . . . *a sh*
*like this is painfully associated with European colonists arriving in North America to take indigenous lands, or of slave ships crossing the Atlantic. It's chilling to loc
at considering the violence, suffering and death brought by ships like Ruscha's to BIPOC people."*

the work his brother was doing with a Russian prince. Though this concept of monitoring human bodies was tied to labor, Bentham continued to build on it and applied it to the idea of controlling behavior, especially as a prison.

This of course manifested in some of the very real prisons, a few of which have been in the U.S., one in Cuba that's abandoned, that I've seen. Foucault built upon the idea of the panopticon as a concept for strengthening self-policing, especially when one perceived that they were being monitored or watched.

Then I think about the digital panopticon, and what happens when we've all opted into the panopticon and ceded our power? Then in what ways do we have to then think about what liberation is in this context of the digital panopticon?

While planning the exhibition, I wanted to create a panopticon. I needed to do my own version of a panopticon in a way that would inspire disrupting our tendency to self-monitor, self-police, or engage with seeing within museum space. In thinking about how one is seen or sees, it is also about resistance–specifically as it relates to the concept of different kinds of forcibly traveled bodies. Like many representations of the female body in art, it is easy to see a passivity or victimhood.

How do we take something that, yes, has been forcibly traveled like many different kinds of bodies–the black body, the female body, or the intersection of the two–how do you find the resistance upon a closer look? Not just at a photograph, but also at something like the way an artifact and its provenance challenges what we think we know of it through its silences. What is potentially missing and what is the power in what we do not get to know or have in our exchange in the contact zone that is the museum space? This kind of silence puts us all on notice—institutions, intellectuals, artists, all of us—it checks all of us.

The silence and trying to fill in the blank becomes a bad game of telephone because in many instances, even if you do use Google, you are either swimming in misinformation or no information. If we are trying to follow the lines of acquisition through a range of extraction along a continuum of violence, we notice the context has either gone missing or is distorted. In my planning, I noticed how the space and all the things within it became my collaborators. They were and are also disruptors, and they were not going to neatly go even where I would want to put them.

An illustration of Jeremy Bentham's concept of the panopticon as the ideal prison, of which he said, *"Morals reformed - health preserved - industry invigorated - instruction diffused - public burthens lightened - Economy seated, as it were, upon a rock - the gordian knot of the Poor - Laws are not cut, but untied-all by a simple idea in Architecture!"*

The panopticon makes this claim to be all-seeing and all-knowing.

Yes, right.

It's spatially set up this way. You are looking for how the gaze on these objects actually makes you aware of all the things that you don't know and all the things that you can't know, and then refracts that desire back onto you.

Yes, exactly. This is why they become very active. There's so much you want to know. At the same time, you're not going to know. Even in my approach for the quasi-fiction piece I wrote for this publication, for the exhibition, I had to think about how to illustrate the missing that is only known to that artifact and its full cultural context. It also inspired me to think about how to structure or architect an absence for a few of the artifacts that have complicated histories

within the Fleming's collection. Specifically, artifacts like the mummified person or the Benin sculpture, I wanted their absence to be felt and witnessed given all of the ways they've been seen for so long out of their original contexts within the same space.

This conversation about disrupting the gaze makes me think about the formal qualities of the photographs themselves and the way that the light is dappled. The dappled light is one of my favorite formal qualities of the photographs. How is that dappling working to disrupt the gaze? Is it a diffusion of the piercing gaze? Is it a confusion of that ever-present eye that sees from every direction? Instead, you have these shifting shadows and light. It's disrupting that sense of uni-directionality of the panopticon. It seems to be suggesting a way of looking that's more subjective, that really changes depending on where you're standing and moving.

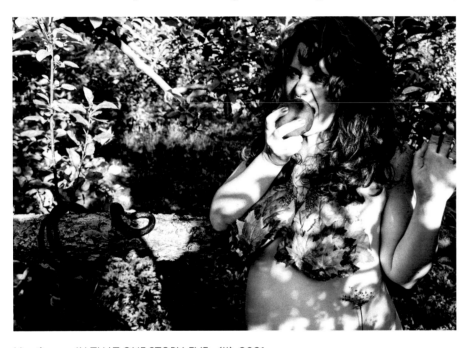

Heather as *IN THAT ONE STORY, EVE...(II)*, 2021.

Dappling is interesting, because it also discloses my obsession between the seen and unseen, visibility and invisibility. In some of the lectures that I've given, I've talked about growing up with the edict, *children are to be seen, not heard*. I was not allowed to ask questions in my household. If there were adults around and I happened to be the only kid in the room, an adult occasionally would turn to me and say, "Did you hear that?" And I'd say, no. Of course I was lying. Around 12 or 13, I started writing and keeping journals to record what I could not talk about. Over the years, this writing helped me to recognize the power that invisibility has and the power of walking between seen and unseen.

Invisibility is also dicey because it's potentially dangerous. It's where things can happen to one's body. It's where the theft takes place when no one's looking. And at the same time, if one becomes aware or engaged with this concept of invisibility, they get to play with that in the way that the dappling happens upon a body or upon a face within photographic images. In my work, it is a purposeful confusion. It is about what do we choose to see and what do we choose to not see? Much in the same way that seeing any European gallery filled with portrai-

ture... what was I choosing to see all those years? I refused to see the privilege. Or in one way I did see the privilege, but I wanted to see how I too could get that privilege. But then what kind of privilege was I trying to get access to?

The dappling plays a role to reflect back onto the viewer what it is they believe they are seeing with the interplay between what is seen and not quite seen. Within another level of meaning, this question about the use of dappling also reminds me of the way a couple of the models talked about how we juxtapose the ideas of light and dark as concepts within our culture. This has caused me to reflect on the ways that the concept of doing "shadow work" is becoming a buzz word within certain communities, yet, I don't think the people using this term really understand the concept of the shadow. For us to truly engage with that work, it means you're willing to recognize and go into places that are so unseen, even to yourself.

That is where, for me, the sweet spot lives. It also reminds me of Johari's window, a self-awareness model created in the early 20th century. What is that spot, that square where everyone else and myself do not know? And all of the other areas that we play with in those quadrants of that concept. That for me is what the representation between the light and dark is within my work.

The Johari Window

	What I know about myself	What I don't know about myself
What others know about me	**OPEN BOOK** What I know about myself and what others know about me.	**BLIND SPOT** What I do not know about myself but what others know.
What others dont' know about me	**MASK** What I know about myself and what others do not know.	**UNKNOWN** What I don't know about myself and what others don't know about me.

The Johari Window was created by Joseph Luft (1916–2014) and Harrington Ingham (1916–1995) in the mid-1950's, and is rooted in the self-help movement.

That's the dialectic again, right? The light and the dark are happening at the same time. That back-and-forth aspect is what illuminates the new ways of understanding. This quality helps me think about the power that your work has when you're doing this work of articulation. You are throwing together so many different thinkers and theories, your own work, visual material, and objects from the museum. In an artist's talk, a Powerpoint, or any kind of presentation, you have to line up all of these things in a way that tells a narrative. What do you get from the constraint of having to articulate in a verbal form, what the visual maybe lets you only suggest?

It's funny because you mentioned narrative. My goal is to disrupt narratives. I decided, even with the memoir that I'm working on, I am disrupting narrative, narrative arc, show don't tell, all that. There is a constraint within that. As I have been creating the alternative titles and labels for the items within the museum's collection, I've had to ask myself: what decisions am I making on purpose to ground and displace the reader such that I'm not making them dizzy?

In approaching the alternative titles and labels, and thinking about the idea of dialectic given the many silences among the artifacts that I mentioned earlier, it presented a constraint for me as a writer. I had to think about leveraging the known and unknown in ways that connect the viewer to the experience within the exhibition. For example, how do I encourage people to think about venturing beyond just physically seeing themselves within this space, but to "see" their thinking while in this space? Or pose questions of themselves like:

How do I, the artist, free my thinking or my gaze? How do you, the viewer, need to free yourself from your own thinking? How do you need to think about liberation within a context where that is becoming a buzzword? How do you make your own connections between my photography and the artifacts? How does this space of the exhibition encourage you to look back at yourself, your thinking?

How do you encourage yourself to reject norms that do not fit what people expect when they "see" you? Are you being your best, most raw and obscene self that you can be?

I know that sounds really insane, but the concept of the obscene comes from the wisdom within Dr. Clarissa Pinkola Estés's book, *Women Who Run With the Wolves: Myths and Stories of the Wild Woman Archetype.* This text has been in my life for so long, this copy of my book is falling apart! She talks about the root of obscene as *ob* and *ob* being linked to sorceress. I began thinking about that and I was thinking, 'Okay, so what or who has been my ob, especially if we're talking about the Dark Goddess?' And what is that within ourselves? Especially in this period of re-enchantment, this is a period in which people are reengaging with all sorts of things, along with asking this key question: are we truly engaging? We are seeing this with the Great Resignation, where people are leaving their jobs rather than continuing to do what numbs them.

I know I used the word police before, but I don't want people to police themselves. I want them to go home and think about how they are resisting. Within this exhibition, I am asking viewers to notice the subtleties of resistance. . .

I know I used the word police before, but I don't want people to police themselves. I want them to go home and think about how they are resisting. Within this exhibition, I am asking viewers to notice the subtleties of resistance in a way that people may not be accustomed to, especially when they look at artifacts.

It feels like an exciting thing to ask visitors to do: to confront the ways that they think that they know the world and to make those constraints visible, and then

to introduce them to the sense of being able to live through those contradictions. And then to see that contradiction-filled life as something that possibly points towards liberation. Certainly resistance, then possibly liberation. What has this conversation brought up for you in making your own thinking visible that is part of that liberation?

It's brought up for me the ways that I dappled my life in terms of what I will expose of myself and what I won't expose of myself. Speaking of panopticon, I was raised to believe that someone's always watching you. I was told that to a point where I'd look around while walking to elementary school and, I'm like, *are the bushes watching me*? I've been hypervigilant most of my life given how aware I am of the perceptions of others. Hence, it's not surprising that I'm obsessed with the idea of the panopticon, because I've been my own panopticon and I refused to be just the body that was viewed. I knew I was also a viewer. In knowing that I was viewed, I was going to control how I was going to be viewed, but also ask myself uncomfortable questions. As someone who wears corsets proudly, as someone who would venture into territory of objectification, even.

But I resist, I reject the wholesale meaning of objectification, even with the complexities of the history of Black women's bodies and Sarah Baartman, the so-called Hottentot Venus, who did not have control over her viewing. It's very complicated, but that all is stitched within my bones, alongside my indigenous heritage, alongside other kinds of heritages that clash with each other.

In other words, this experience, this exhibition, the work I will continue with, has called me to the carpet in a way. As I am asking and as I've asked people and invited them to be vulnerable, and as I've invited these artifacts to be very vulnerable, then that also means I have to level up as well. I can't just be the one who gets to wield the camera and the words without shining a lens on myself as well.

In having the power to create, I've also had to be vulnerable.

You're an artist whose work can depict that vulnerability, but in this exhibition you're also acting as a curator who can explore that vulnerability by inquiring about alternatives to that will to knowledge and power that museums often put up as a front. We don't often associate those words of *vulnerable* and *curator* together, but maybe that's actually the way that you break open the idea of the gatekeeping role of a curator's care; say: how can we be vulnerable together in this museum? Even though the museum is not a safe space, it is a space where you are constantly noting your contradictions. That's really different than a safe space. It's a contradictory space, but making those contradictions visible and facilitating that sort of disruption feels both exciting, but also, yeah, vulnerable.

I don't even know what a safe space would look like because we've been using that language a lot. It occurs to me that no space is safe. If you're standing on a ground, you might be standing on a mass grave and you may not know it. Is that a safe space? Well, a safe space for you,

but not safe space for the bodies beneath your feet. So it's very interesting, even that concept of the safe space. Some space is less safe than others and the museum being that disruptor in the sense that it isn't safe, but you somehow feel safe because what you're seeing is controlled. There's a controlled element to how you can get up close and personal with things that you normally would never be close and personal to.

Museums are in some ways realizing that they can't say they are safe spaces anymore. They never were, but they're transforming into something that makes their violence visible, but also wants to invite more, different people into that at the same time. Talk about a contradictory space! That is a really vulnerable space to invite people into.

Yeah, it is. As I think about this position that museums are in, I also have MBA training, so I'm also thinking: business model. If your business model was always that you're bringing these things from all around the world, all the different cultures, you are a contact zone. In this current environment, you are admitting to or grappling with how you've gotten those things in violent and sometimes immoral, unethical—even if it seemed ethical on the surface—ways. In terms of the bottom line, it means that you risk who is represented on your board of trustees. You risk donors. You are risking your very livelihood. You're risking people calling into question why these institutions should exist. It's all these things that become the ways that museums are risking their very bread and butter. And that, I think, is a very interesting position to be in and a scary one.

A vulnerable one itself.

Vulnerable, yeah.

Institutions aren't used to seeing themselves that way.

No, they're not.

Or they're used to seeing a structural problem. How can we fix this immediately, rather than how can we sit with this?

You're right about that because it's like, not everything has a solution. There are certain conversations in my *Black Metamorphoses* collection where there's some things that have no solution, especially with the way the book ends. There is no solution. There's clearly a persona who is angry, rageful, and at times trying to grapple with. Some things, like the Fleming Museum of Art deciding to dismantle the African and Ancient Egyptian gallery was huge. You looked at a gallery that couldn't just be "fixed" with updated information: everything about its organization and even its existence demonstrated its colonial assumptions about how to objectify and exotify people.

That act also raises questions about the architecture of invisibility: how do we read what is not there or no longer there in the ways we were trained to see? What do you see instead? But that's one of many steps in the same way that multiple steps are involved in an institution deaccessioning and repatriating an artifact. The deaccession is not the final step towards reparations, but one stop along a complicated road of healing.

What does this scenario of seeking a solution look like when you know that the so-called solution involves discomfort, dialogue, and discourse? Maybe that's the only solution that could be gotten, because you could give stuff back or you go through more of the collection and say, "Wow, this really doesn't belong here." That's still not necessarily a solution. There are still so many things to grapple with.

Well, this has been great. Is there anything else that you want to sort of throw out there?

I am going to put something out there, a line from one of the artifacts in the collection and something that kind of speaks to what the Fleming Museum of Art has been grappling with in your 2020 exhibition *Reckonings* and your other "Fleming Reimagined" work.

These lines I share are from the John Davis photographs of the Samoan women from the late 19th century, also featured in "Object-Defied" within this publication, and I think it is fitting to let them have the last word:

I give you noticing and leave you reckoning

Notice the way we stare, we refuse you the dignity of connection
Notice the way some of us slightly slouch,
we refuse you the respect of straightened spines
Notice the direct gaze that threatens, that blooms the uncomfortable
We refuse you paradise through our mouths

We refuse enigmatic smiles. We are no one's Mona.

Works

Works in the Exhibition

Page numbers appear at the end of entries for works illustrated in this catalogue. Dimensions are in inches, followed by centimeters; height precedes width precedes depth.

Photographs by Shanta Lee Gander
All archival pigment prints, courtesy of the artist.

1. *OBEAH'D (I)*, 2021
30 1/8 x 40 (76.6 x 101.6)
PAGE 13

2. *CROW GODDESS*, 2020
26 3/4 x 40 (68 x 101.6)
PAGE 1 (DETAIL), PAGE 15

3. *IN THAT ONE STORY, EVE...(I)*, 2021
26 11/16 x 40 (67.7 x 101.6)
PAGE 17

4. *IN THAT ONE STORY, EVE...(II)*, 2021
27 1/4 x 40 (69.3 x 101.6)
PAGE 68

5. *THE MORRÍGAN*, 2020
26 11/16 x 40 (67.7 x 101.6)
PAGE 19

6. *SHE... KILLER OF BAD MEN (I)*, 2020
33 15/16 x 40 (86.1 x 101.6)
PAGE 21

7. *HECATE*, 2020
26 11/16 x 40 (67.7 x 101.6)
PAGE 23

8. *DARK APHRODITE*, 2021
28 x 40 (71 x 101.6)
PAGE 25

9. *SHE... KILLER OF BAD MEN (II)*, 2020
26 11/16 x 40 (67.7 x 101.6)
PAGE 11 (DETAIL)

10. *OBEAH'D (II)*, 2021
26 11/16 x 40 (67.7 x 101.6)
PAGE 50 (DETAIL)

11. *DARK APHRODITE*, 2021
26 3/4 x 40 (68 x 101.6)

12. *YOU WILL OBEAH (II)*, 2021
26 11/16 x 40 (67.7 x 101.6)
PAGE 27

13. *ORIGINAL BERSERK*, 2020
26 11/16 x 40 (67.7 x 101.6)
PAGE 29

14. *YOU WILL OBEAH (I)*, 2021
32 3/16 x 40 (81.7 x 101.6)
PAGE 31

Finding the Dark Goddess: A Short Film, 2021-22
Digital video, 14 min 35 sec

This film montage features original footage, as well as clips from the following sources:

1. Darren Aronofsky (b. 1969), *Mother!*, 2017
2. Robert Eggers (b. 1983), *The Witch*, 2015
3. Michael Rymer (b. 1963), *Queen of the Damned*, 2002
4. Leah Rachel (b. 1985), *Chambers*, 2019
5. Julia Hart (b. 1982), *Fast Color*, 2019
6. Bryan Fuller (b. 1969) and Michael Green, *American Gods* (Seasons 1 & 2), 2017
7. Luca Guadagnino (b. 1971), *Suspiria*, 2018
8. Pieter Kuijpers (b. 1968), Iris Otten (b. 1977) and Sander van Meurs (b. 1974), *ARES* (Season 1), 2020
9. Bruce Miller, *The Handmaid's Tale*, 2017
10. Satyajit Ray (1921-1992), *Devi*, 1960
11. Ari Aster (b. 1986), *Midsommar*, 2019
12. Oz Perkins (b. 1974), *Gretel & Hansel*, 2020
13. Brian De Palma (b. 1940), *Carrie*, 1976
14. Ari Aster (b. 1986), *Hereditary*, 2018

Objects from the Fleming Museum's Collection
Accompanied by artist Shanta Lee Gander's alternative titles.

DISPATCHES FROM SAMOA

Unknown artist (Samoa)
Skirt, about 1892-93
Grass fibers, 20 x 30 (50.8 x 76.2)
Gift of Carrie Ormsbee 1927.1.43
PAGE 37

CARRIE MAE WEEMS

Carrie Mae Weems (United States, b. 1953)
Untitled, from *The Kitchen Table Series*, 1990
Photograph, 10 1/4 x 10 (26 x 25.4)
Museum Purchase, Way Fund, in honor of William McDowell 2011.3

THE CONVERSATION

Howard Chandler Christy (United States, 1872-1952)
Americans All!, 1919
Lithograph on paper, 40 x 26 3/4 (101.6 x 67.9)
Gift of Beatrice Samuelson 1985.3.8
PAGE 35

Alonzo Earl Foringer (United States, 1878-1948)
The Greatest Mother in the World, about 1918
Lithograph on paper, 46 1/4 x 29 3/4
(117.5 x 75.6)
Transfer from Howe Library 1973.57.20
PAGE 34

Unknown artist (United States)
Wedding Dress, 1857
Off-white damasked silk taffeta and gold silk fringe, 54 1/2 x 21 (138.4 x 53.3)
Gift of Professor and Mrs. Malcom D. Daggett 1970.7.1
PAGE 35

YOUR ALBUMEN CONCUBINES. READY. FROZEN. HOSTAGE.

John Davis (born Britain, about 1831-1903)
Studio Portrait of 3 Samoan Women, about 1890
Albumen print, image: 5 x 4 (12.7 x 10.2); sheet: 6 1/2 x 4 1/2 (16.5 x 11.4)
Gift of The Vermont Historical Society, from the Carrie Ormsbee Collection 1990.17.14 LA
PAGE 37

John Davis (born Britain, about 1831-1903)
Women Making Kava, about 1892
Albumen print, 8 x 10 (20.3 x 25.4)
Gift of Mrs. F.H. Brown (from Elihu Taft Estate) 1948.30.30
PAGE 36

IN THE HOUSE OF THE LOTUS

Unknown artist (China)
Shoe for Bound Foot, late 1800s
Embroidered cotton and cork, 2 3/4 x 3 1/2 x 1 1/2 (7 x 8.9 x 3.8)
Gift of Ann Porter 2002.14
PAGE 38

SHE-WHO-IS-AND-SHE-WHO-IS-NOT

Unknown artist (Mende Peoples, modern-day Sierra Leone)
Sowo Initiation Helmet Mask of the Sande Society, 1800s
Wood, 15 x 8 x 9 (38.1 x 20.3 x 22.9)
Museum purchase 1972.30.1
PAGE 41

A GEISHA WHO NEVER WAS

Unknown artist (Japan)
Kimono, 1800s
Brocade silk with stencil painting and embroidery, and pongee lining, 48 x 22 x 10 (121.9 x 55.9 x 25.4)
Gift of Katherine Wolcott 1933.37.32B
PAGE 42

THEY SAY,

Unknown artist (Egypt)
Goddess figure or amulet, 100s B.C.E.-100s C.E.
Bone, 2 x 1/2 x 1/8 (5.1 x 1.3 x .3)
Gift of Henry Schnakenberg 1963.20.7

QUEEN MOTHER SPEAKS

Unidentified artist (Edo Peoples, Kingdom of Benin, modern-day Nigeria)
Head of a Queen Mother (Iyoba), 1700s-1800s
Copper alloy with iron insets (lost wax casting), 16 x 6 1/2 x 7 (40.6 x 16.5 x 17.8)
Gift of Henry Schnakenberg 1936.51.1
PAGE 44

NOTE: *Not on display, but represented in exhibition with a label*

LAULII WALLIS

Unknown artist
Portrait of Laulii Willis, about 1890
Albumen print, image: 5 3/4 x 4 (14.6 x 10.2); sheet: 8 1/4 x 6 1/2 (21 x 16.5)
Gift of The Vermont Historical Society, from the Carrie Ormsbee Collection 1990.17.15 LA

BEHOLD

Unknown artist (United States)
Corset, early 18oos
Cotton and metals
18 3/4 x 25 (47.6 x 63.5)
Museum Collection T2168

WOMAN UNTITLED

Unknown artist (Kingdom of Nicoya, modern-day Costa Rica)
Effigy Bottle, 500s-800s
Fired clay, 7 1/4 x 6 x 5 (18.4 x 15.3 x 12.7)
Gift of Otis Warren Bennett 1928.1.99

IN THEIR IMAGE

Unknown artist (Luba Peoples, modern-day Democratic Republic of Congo)
Statue of Mother and Child, 1800s or early 1900s
Wood, 16 x 4 1/2 x 4 1/2 (40.6 x 11.4 x 11.4)
Gift of Mr. and Mrs. Ray L. Smalley 1931.7.26

IN THE BEGINNING WAS THE WORD AND THE WORD WAS NEITH

Unknown artist (Egypt, Late Period, about 664 - 332 B.C.E.)
Neith, Goddess of War, 400s-200s B.C.E.
Bronze, 5 3/4 x 1 x 1 1/2 (14.6 x 2.5 x 3.8)
Gift of Mrs. Thomas Brown 1957.1.2

I AM WHO I AM, HISTORY SAYS...

Unknown artist (India, Deccan, probably Aurangabad)
Queen with her Horse and Falcon, early 1700s
Opaque watercolor on paper, 8 1/2 x 5 (21.6 x 12.7)
Gift of Dr. David Nalin 2006.14.6

MUMMY FEVER

Unknown (Egypt, Dynasty 26)
Sarcophagus and Mummy of an Unknown Man, 500s B.C.E. or later
Human remains wrapped in linen, with paint on fiber and plaster; paint and gesso on wood, 18 1/2 x 73 x 15 (47 x 185.4 x 38.1)
Purchased from the Egyptian Museum, Cairo 1910.3.119
PAGE 43

NOTE: *Not on display, but represented in exhibition with a label*

Suggested Reading & Viewing

This is an abbreviated list of some of the readings, films, and television that have inspired this work over the years.

SUGGESTED READING

Baring, Anne and Jules Casford. *The Myth of The Goddess: Evolution of an Image*. New York: Penguin, 1993.

Bentham, Jeremy. *The Collected Works of Jeremy Bentham*. https://www.ucl.ac.uk/bentham-project/collected-works-jeremy-bentham.

Berger, John. *Ways of Seeing*. New York: Penguin Books, 1990.

Dieleman, Jacco. "Fear of Women? Representations of Women in Demotic Wisdom Texts." *Studien zur Altägyptischen Kultur* Bd. 25 (1998): 7-46. https://www.jstor.org/stable/25152752.

Campt, Tina M. *A Black Gaze: Artists Changing How We See*. Cambridge, MA: The MIT Press, 2021.

Dodge, Edward. *A History of the Goddess from the Ice Age to the Bible*. Walterville, OR: Trine Day LLC, 2021.

Globus, Doro, ed. *Fred Wilson: A Critical Reader*. London: Ridinghouse, 2011.

Eileraas, Karina. "Reframing the Colonial Gaze: Photography, Ownership, and Feminist Resistance." *MLN* 118, no. 4, French Issue (September 2003): 807-840. https://www.jstor.org/stable/3251988.

Estés, Clarissa Pinkola. *Women Who Run with the Wolves: Myths and Stories of the Wild Woman Archetype*. New York: Ballantine Books, 1992.

Hewitson, Owen. "What Does Lacan Say About... Desire?" LacanOnline.com. Published May 9, 2010. https://www.lacanonline.com/2010/05/what-does-lacan-say-about-desire/.

hooks, bell. *Black Looks: Race and Representation*. New York: Routledge, 1992.

Miller, Jacques-Alain, ed., and Alan Sheridan, trans. *The Four Fundamental Concepts of Psychoanalysis: The Seminar of Jacques Lacan Book XI*. New York: W.W. Norton & Company, 1998.

Mulvey, Laura. "Visual Pleasure and Narrative Cinema." *Screen* 16, no. 3 (Autumn 1975): 6-18.

Shaw, Gwendolyn DuBois. *Seeing the Unspeakable: The Art of Kara Walker*. Durham, NC: Duke University Press, 2004.

Stone, Merlin. *Ancient Mirrors of Womanhood: A Treasury of Goddess and Heroine Lore From Around the World*. Boston: Beacon Press, 1979.

Walker, Barbara G. *The Women's Encyclopedia of Myths and Secrets*. New York: HarperCollins, 1983.

Wolkstein, Diane, and Samuel N. Kramer. *Inanna: Queen of Heaven and Earth, Her Stories and Hymns from Sumer*. New York: Harper Perennial, 1983.

Suggested Viewing

Argento, Dario, dir. *Suspiria*. 1977; Rome: Seda Spettacoli.

Aronofsky, Darren, dir. *Mother!*. 2017; Hollywood: Paramount Pictures.

Aster, Ari, dir. *Hereditary*. 2018; New York: A24.

Aster, Ari, dir. *Midsommar*. 2019; New York: A24.

De Palma, Brian, dir. *Carrie*. 1976; Beverly Hills, CA: United Artists.

Eggers, Robert, dir. *The Witch*. 2015; New York: A24.

Fuller, Bryan, and Michael Green, creators. *American Gods*. Aired 2017-2021 on Starz.

Guadagnino, Luca, dir. *Suspiria*. 2018; Culver City, CA: Amazon Studios.

Hart, Julia, dir. *Fast Color.* 2019; Santa Monica, CA: Lionsgate and Codeblack Films.

Kuijpers, Pieter, Iris Otten, and Sander van Meurs, creators. *ARES*. Aired 2020 on Netflix.

Miller, Bruce, creator. *The Handmaid's Tale,* Aired 2017-2021 on Hulu.

Perkins, Oz, dir. *Gretel & Hansel*. 2020; Beverly Hills, CA: United Artists.

Rachel, Leah, creator. *Chambers*. Aired 2019 on Netflix.

Ray, Satyajit, dir. *Devi*, 1960.

Rymer, Michael, dir. *Queen of the Damned*. 2002; Burbank, CA: Warner Bros. Pictures.

Thomason, Dustin, and Sam Shaw, creators. *Castle Rock*. Aired 2018-2019 on Hulu.